g<small>ush</small>

gush

yo hemmi

Translated by Giles Murray

COUNTERPOINT | BERKELEY

Each story originally published under the Japanese titles of
Akai hashi no shita no nurui mizu (Gush),
Naito kyaraban (Night Caravan), and
Myujikku waia (Piano Wire)
by Bungei Shunju in 1992, Tokyo.

Japanese names appear in Western order, given name first, rather than in Japanese
order, surname preceding given name.

Library of Congress Cataloging-in-Publication Data

Henmi, Yo, 1944–
Gush / by Yo Hemmi ; translated [from the Japanese] by Giles Murray.
 p. cm.
Hardcover ISBN-13: 978-1-58243-625-8
Paperback ISBN-13: 978-1-58243-626-5
I. Murray, Giles. II. Title.
PL852.E48A2 2010
895.6'36—dc22
2010017807

Cover design by Gopa & Ted2 Inc.
Interior Design by Elyse Strongin, Neuwirth & Associates, Inc.
Printed in the United States of America

This book has been selected by the Japanese Literature Publishing Project
(JLPP), an initiative of the Agency for Cultural Affairs of Japan

COUNTERPOINT
1919 Fifth Street
Berkeley, CA 94710
www.counterpointpress.com
Distributed by Publishers Group West

10 9 8 7 6 5 4 3 2 1

. Contents .

gush

gush

i want to tell you about something that once happened to me.

It wasn't that long ago, and it tied in with a pet theory of mine: that everything in this world is connected with everything else—that "what goes around comes around," in chains of events. Let's say you have a single cabbage butterfly fluttering around a puddle in some remote little town. Its tiny wings make the air vibrate ever so slightly and, bit by tiny bit, the puddle starts evaporating. Well, I was convinced that whole worlds were created and destroyed through the sequence of countless insignificant events like this. The first vibration in the air provokes a second, and the vapor being sucked up into the atmosphere amplifies it until, one thing leading to another and another, the rain comes bucketing down somewhere several hundred kilometers away. I don't need to tell you that there's an infinite "before" prior to the butterfly doing anything and an endless "afterwards" following the downpour. In this world of ours, the trifling and the far-reaching

come around one after another like a ribbon of memories with no beginning or end. That was my philosophy at the time when the mystery of it all was brought directly home to me.

If I could, I wanted to track the vibration of the air and ride the path of the wind on my own solitary journey from the first single flutter of the butterfly's wing all the way to the eventual downpour. That dream stayed with me even after I'd started working for an insurance company. Out of the blue, I had been transferred from the headquarters in Tokyo to a little sales office on Sagami Bay, on the outskirts of the metropolitan area. The events I'm going to tell you about happened then.

It was a Sunday in June in the not-very-rainy rainy season. I guess I'd probably been in my new posting about a month. I had gone shopping at Kanekoya, the supermarket near the station. It was there that the whole episode started.

Cheese

A woman with a wonderfully long neck was standing by the cheese section. Short-necked though I was myself, I found myself gazing raptly at her neck from the next-door bread department. It wasn't just long, you see; it was slender and elegant and didn't have even a single wrinkle. She reminded me of a flamingo. Her hand stretched out to pick up a leaf-shaped slice of what was presumably some kind of cheese between her thumb and her index finger and dropped it casually into her handbag as though it were just a dirty hanky. Hey! Isn't that called shoplifting? The fact is, it took me a couple of seconds to realize what she was doing.

The woman should have made a quick getaway but she stayed right where she was. She looked a bit strange. I wondered what was wrong with her. Her eyes were open wide, and her thin, pink

lips were drawn tight and quivering, as though she was trying to make it through an unpleasant experience. Then, looking toward the "Imported Cheese" sign without actually seeing anything, her brown eyes began to shine. Some powerful force seemed to be at work in her, and the energy from inside her body radiated from her eyes. The skin of her long white neck twitched as though some tiny bug was scuttling to and fro beneath it. Her gold earrings were swinging about. The curve of the left arm holding the handbag also trembled slightly. From one of her large earlobes, something gold fell shimmering to the floor.

Her flushed face moved toward me. Her long neck was suffused with a beautiful pale pink. Er, excuse me, but you dropped one of your earrings. Over there, see. The woman had already gone past me before I got the words out. The way it stuck to her bottom, her white dress must have been soaked with sweat.

We had changed places and now I was standing where the woman with the long neck had been. I looked for the earring. There was a little puddle of water on the beige floor tiles at my feet. In it swam a single glinting gold earring in the shape of a fish. Puddles are nothing special—you come across them anywhere—but that one was peculiar. Only a moment ago, the long-necked woman had been standing there like a flamingo on the shore, and there was a little golden fish swimming in it too. I picked up the earring. The water was warm on the tips of my fingers.

Before chasing after the flamingo, I had a look at the leaf-shaped cheese she'd stolen. There were five slices left. It was an Italian cheese called *formaggio al peperoncino*; it had orange stripes on its flat body and was oozing inside its cellophane wrapper. I tried to pronounce its long name. I had some notion that saying it would help me understand the flamingo's bizarre trembling fit just now.

Formaggio al peperoncino.

Turning, I saw that she had passed the cash register and was on her way out. A single gold fish glinted in one of her ears. Clutching the other one, I dashed after her, passing Miss Kawashima dressed in plain clothes with a quick "Oh, hi there" nod as I went. She glared at me, didn't say a word. Kawashima was the first woman I had made my sales pitch to here—and the first to turn me down. Her job at Kanekoya was to catch shop-lifters masquerading as proper little housewives. It's the posh-looking pigeon-toed women who pinch stuff, she told me. She had round shoulders, her thick, solid body always making me think somehow of a wild pig. It wasn't just pigeon-toed women she regarded with suspicion.

The lady with the long neck was hurrying down the passage on the ground floor of the building toward the parking lot. She was certainly very pigeon-toed. I ran after her, looking repeatedly over my shoulder to check if Miss Kawashima was also in pursuit. I came out into the parking lot. The sudden glare of the sunlight turned everything around me into a blinding screen of white. I blinked, then saw a hairy, sunburned arm reach out from the parking lot attendant's booth to hand a white arm reaching from the other direction a set of car keys. Attached to the pale arm was a long neck.

I was behind her and off to one side when I spoke. "Um. Excuse me." The woman stiffened at the sound of my voice. It took her three long seconds to turn around and face me. By the time she had turned she was no longer alarmed. The redness had gone from her neck, and her face was as cool as the underbelly of a fish.

"Is it about the cheese?" she asked wearily. The way she said the word "cheese" almost melted in my eardrums, but after

taking in her blasé-sounding question, I opened up my fist and showed her the wet, fish-shaped earring.

"No, not the cheese. You dropped something. I think this is yours."

The moist metal fish swam over onto the palm of her hand. She gave no immediate sign of being pleased. Her big, brownish eyes locked onto mine. I tried to look away, but the brown eyes pursued me, and she asked me another question.

"Did you see?"

I tried a question of my own.

"See what?"

"Everything," she said, and that wonderful long neck swayed off toward her car. She was half a head taller than me as I walked beside her. I tried to reassure her; I wasn't a security guard or anything like that, and handed her my business card. "At your service," I told her. As I spoke, I peered back over my shoulder to make sure Miss Kawashima wasn't watching us. That was when I heard a faint sound like someone walking through shallow water coming from her feet. It was probably just my imagination. I deleted it from my mind. But the slish-slosh sound continued.

"*Formaggio al peperoncino* . . . really that good, is it?" I took care not to sound critical. The ground underfoot was uncomfortably hot. She thought about my question as she walked along in her pigeon-toed way. There was the sound of water again. It almost blotted out her voice.

"You promise not to tell anyone what you saw?" she said with feeling.

"Why should I ever tell any—?"

She butted in before I had finished, her words over mine. "Never tell anyone! Ever!"

"Why should I ever tell anyone anyway?"

She was standing with a white car door behind her. It served as a backlight. Her brown eyes, I think, were looking into mine. Her hands slithered gracefully up her neck and put the metal fish earring onto her naked ear. I felt dazzled, giddy.

"What should I do with the cheese, then?"

She undid the clasp of her handbag and reached for the *formaggio al peperoncino*.

"Going back and paying for it now'll only make things more complicated." The voice that came out of my mouth was raspy.

"Shall we eat it? Sometime soon. You and me together." As she spoke, she lowered her hips into the driver's seat and folded her white legs in after her. Her shoes hung for an instant in mid-air. Something silvery dripped from the heels of her tilted shoes.

. . . Water?

The hot concrete swallowed it with a hiss. The darkness of the car absorbed the white legs from the crotch on down, and the door was pulled to with a dull thud. White cut off my view. The car drove off. I looked down at the concrete. No stain. Not one. A lone white butterfly flew around my knees.

Multi-Month Campaign

It was a strange encounter. The memory of the woman stayed with me, as lurid as a bad photograph.

You see, we met just when the head office and all our hundred and fifty branches throughout the country were about to get stuck into a Multi-Month Campaign. The Multi-Month Campaign is a big push to sell more policies; it swings into action in June or July in the lead-up to the anniversary of the founding of the company. All the sales outlets are given quotas they have to meet, and even proper full-time employees from the head office

like me are forced to do the same door-to-door sales as the sales-women on renewable contracts. It wasn't really the best time for me to be thinking about anything else.

Still, whenever the door of some unfamiliar house opened, I always hoped that the woman with the long neck would come out. I don't know why, but I couldn't bring myself to believe that the whole business at the supermarket had just evaporated, vanished into the June sky without a trace. Before pressing the buzzer on the intercom, I chanted a little formula to myself: Flamingo, fla-mingo, out you come, out you come. But the necks that emerged at the door were short like owls or thick like dogs; and the very few long ones were as wrinkled as an old pair of bellows.

Dressed in my gray off-the-peg suit, I would expound with missionary fervor on low premiums and peace of mind as I trekked around dishing out free greaseproof paper and measur-ing cups. My stock of greaseproof paper and measuring cups cer-tainly declined, but I never managed to sell even a single policy. I'd been given the west end of a newly developed residential dis-trict—a place where the people were supposed to be relatively receptive to sales—but eventually I was reassigned to the east end. Not only were most of the residents there local people and that much more hardheaded, but I couldn't even work out the geography of the place. Every day it was swelteringly hot. Not surprisingly, I didn't sell any policies. And I didn't run into the long-necked woman, either.

The Bridge

I was leaning over the rail of a bridge feeling completely flum-moxed. Long and limp like a boiled snake, the river didn't move. It was so hot that the whole world seemed to have given up on

events happening in chains and cycles. Only the carp under the
bridge had any energy to spare.

Apart from me, there were a couple of skinny black guys on
the bridge who looked so alike that they could have been twins.
They had on matching yellow trainers and were leaning right
out over the balustrade yelling something as they threw bread-
crumbs to the carp. They each had a single silver earring in one
ear. Their outfits and their movements were identical. I thought
I'd gone cross-eyed and was seeing double.

Countless flesh-colored holes gaped on the surface of the
river: the mouths of the fish. The mouths pushed and shoved
one another as they fought for the crumbs. Blinking, I looked
at the carp and the two men. I realized that it didn't matter how
hot a day it was, the world hadn't given up on things happening
in sequences and cycles after all. The black twins had flown over
here from the States; they had gone all around Japan; and now
here they were, feeding fish with breadcrumbs from this bridge.
Each of the carp that were gobbling down the bits of bread being
fed to them by the black twins who had flown over here from the
States would put on a couple of grams and eventually have baby
carp . . . I started to imagine the chain of events.

The visible world suddenly turned green. I looked up to
find a green parasol over my head. A faint smell of fresh grass
floated just below the canopy. A woman's pale, lucid face. A long
neck beneath it. A flamingo neck. I was flustered, but the neck,
together with the parasol, slowly inclined itself toward me.
"Thanks for what you did the other day," said the woman. She
told me she'd spotted me from the fruit shop at the end of the
bridge where she'd been buying some oranges.

She leaned out over the railing. When she emerged from under
the parasol her green sleeveless dress turned quite white. There

were four of us now, the two black men, the long-necked woman, and me, all standing in a row on the bridge. Down below, the carp noisily exhaled their muddy breath. With me still nervous and awkward, the woman swiveled her neck toward me and whispered, perhaps to avoid the sight, "See those two black guys?"

She pointed at them with the pommel of her parasol. The green shadow streamed downward, and her profile was dappled with green and white.

"They come down to the river in the middle of the night and wade right in and catch the carp with their bare hands! Thing is, it's illegal. They work at the seafront, those two, where the new *yakiniku* place is being built. As a matter of fact, they're Africans, not African Americans. In the dark, they can't tell the red fish from the black so they just chuck 'em all into a bucket and cart 'em off."

The woman's stage whisper trickled down to the surface of the river, where a multitude of mouths gobbled up her words. I got the impression she was trying to stop the conversation veering off to what had happened at Kanekoya Supermarket. Still, it was an odd topic she'd chosen.

"Then they fry them up that same night. Apparently they even eat the red ones. Or that's what the old man at the fruit shop said. They strip off and go in and grab the fish with the water right up to their waists. He's afraid of them because they're black—that's why he can't tell them not to. 'Moon or no moon, if they turn up at night I'm too scared,' that's what the old fellow says."

I was keen to ask her about the cheese episode at the first opportunity, so I cut her short.

"Don't you think that's just prejudice?"

Looking unexpectedly relieved, she mumbled that maybe it was, then dangled her long neck toward the water in silence.

She handed me the parasol with the sort of backhanded motion used for passing a relay baton. As I held the thing over her, her mouth puckered up and dribbled a white thread of saliva down to the water's surface. The carp opened their mouths wide to swallow it.

"That cheese," the woman said. "Want to come and have some? My place? We can walk it from here."

Without waiting for an answer, she moved away. At the end of the bridge she turned right and walked along the river-bank toward the sea, swinging her bag of oranges. Clutching her parasol and my own black briefcase, I hurried after her. All my unsuccessful door-to-door selling had tired me out, but there was always the chance that she might buy a policy. When I caught up with her and held the parasol over her head, our private sky went green again. Below the embankment the river was so shallow that you could see the bottom. A single red carp lay there, withered and dead.

The woman spoke in a singsong. "My name's Saeko. This river's called the Kikoshi. That bridge there's the First Bridge. Ignore the next two bridges and just go straight on till you come to the one right near the sea. My house is just on the other side of it."

She added: "If you're going by car, you should take the third one. But if you're on foot, then take the fourth, which is pedes-trians only."

I had the wonderful feeling that we'd been destined to move slowly down the river like this, under our green canopy; that it was destiny holding up the parasol, destiny that would let us share the stolen cheese, waiting not far away.

The river was still shallow. We came to the second bridge, all steel and concrete and just as boring as the first one. We—the

parasol and us, that is—didn't cross but walked on. Here and there between the bridges it looked as though the flow of water had been interrupted, but there was always a small thread of water, even only a trickle or two, to keep its continuity.

Saeko was two years older than me. She made Japanese confectionery at home which she sold wholesale to the shops in and around the town.

"I'll make anything. *Kuzumochi* are selling well just now. But they don't keep easily, which is a hassle."

As we came closer to the third bridge, the river was less silted up and the water flowing in a proper stream. On the street above the embankment, a plastic model shop, a bicycle shop, a barber's and a pet shop all stood side by side facing the river. None of them had any customers. The diagonal stripes of the barber's pole were rotating halfheartedly.

Saeko slipped out from under the parasol and made for the pet shop. I followed, parasol in hand, to be met by a pungent smell like Indian spices which made me sneeze. Rabbits, meerkats, marmosets, toucans, prairie dogs . . . In every heat-exhausted body was a pair of kaleidoscopic eyes that fixed us with a lonely, vacant stare. Saeko came to a halt in front of a metal cage at the back of the shop and contemplated a black something-or-other about the size of a fist.

"I want these! Look at their eyes and their noses. They're so cute! I pop in for a look whenever I come this way. Wonder if I could take proper care of them though . . . ?"

They were bats. Two of the things. Bats you couldn't tell apart, just like the black guys on the bridge. A breeding pair, likely as not. "Egyptian Russet Bats: ¥32,000 each," read the label on the cage. Both had their black capes folded elegantly across their chests and were hanging upside down with their

thin toes clamped to the bars of the cage, and with their eyes, which were like blackish-brown beads, wide open.

Saeko suddenly hissed into my ear: "Hey, you won't tell anyone what you saw, okay?"

"Saw? What? These Egyptian Russet Bats, you mean?"

"Not the bats. Before. The cheese thing."

"I'd never tell anyone. Ever."

"Good. Let's go and eat it."

I arranged the green sky again over our heads, to accompany us as we moved along. Past the pet shop was a willow stretching out its branches as though begging the river for water. A dog with a dry nose and its tongue lolling out lay sprawled at its base. Hidden behind the branches stood a two-story house with a sign in the lobby reading Hanamura Iaijutsu Dojo. But it was silent as the grave; there was no one to be seen and no glint of swords in the darkness behind the downstairs window which had been left wide open. The third bridge was about ten paces past the Hanamura Dojo. The Kikujima Obstetrics and Gynecology Clinic, a wooden two-story building, its beige-painted walls peeling to expose the original grain of the old planks, stood at the street corner. I couldn't see anyone silhouetted against the ground glass of its windows; neither could I hear the sound of nurses talking or babies crying. We continued on past the bridge (of the same design as the previous one) without crossing. The shallow stream turned into a bright shining silver mirror. Although I had never been down this street before, from time to time I felt a giddy surge of uneasiness as though I were traveling further and further back into my past along a watery ribbon of memory.

The river was now the same semitransparent green as the parasol. We strolled slowly on toward the fourth bridge. A fish was swimming on the surface with its body turned sideways.

It wasn't so much swimming as thrashing around, flapping its tail as if it had been flung into a pot of boiling water. The fish, I thought, must be hot too. From time to time it lay almost perfectly parallel to the water's surface, exposing the black stripes on its body to the sun and opening its beak-like mouth as it squirmed about. It was a little parrotfish. Wasn't that a sea fish? What was it doing up here then? Why was it heading upstream?

"Look at that fish," I was about to say, when the woman's pale pink lips gave a little wriggle. "Nearly there. Nearly there. My bridge, I mean." Between the "Nearly there" and the "My bridge" I caught a flash of teeth so white that I looked away, to see a bright red bridge there in front of my eyes. It was a wooden humpbacked bridge red enough to make your eyes water.

"Because we're so close to the sea the water here's a mixture of fresh water and seawater. It's funny—river and sea all at once. Brackish, it's called."

I glanced down at the river where the reflection of the bridge's vermilion balustrade was swaying to and fro. The water was blue with a hint of green and seemed to be clinging to the piers of the bridge instead of flowing either up- or downstream. As the woman had said, there was something funny about this bit.

"I wonder if brackish water tastes okay? I mean, you get fish turning up that've really got no business here. Like that parrot-fish we saw. Only brackish-water fish should be able to live in brackish water."

As Saeko was telling me this, she abandoned the shade of the parasol and started to walk in her pigeon-toed way across the bridge. I dithered at the foot of the bridge. Was it the brackish water? I knew, though, that if I didn't cross it, then this intricately linked-up chain of events would be broken. Plus I needed

a nice cold drink of water. I walked out onto the arched bridge. My footfalls reverberated in the space between the shallow, brackish water and the bridge's span.

The Sound of Water

The refrigerated slice of *formaggio al peperoncino* lay on a transparent glass plate on the low dining table secreting cold drops of sweat. Two tumblers of ice water stared down at the cheese with its long, unpronounceable name. There was a single orange at the table's edge that looked like the face of a dumb but amiable old man. The room was so quiet you could hear the sound of the ice cubes clanking one against the other and the "breathing" of the cheese. The window had been flung wide open, but the sound of both the river and the sea had died away.

Settling into a formal sitting position, my mouth still full of unswallowed ice cubes, I began to compare the cheese and the woman's neck. I felt a slightly wistful sense of intimacy with them both.

Saeko's neck was even whiter than the milk-white cheese. A rivulet of sweat trickled its way slowly down from my armpit.

"It's sheep's milk, cream and pepper, with pine nuts and paprika added."

Saeko smiled. The beaded, orange-striped surface of the cheese was dotted with red smudges like subcutaneous bleeding.

"These red blobs, I think they're hot peppers. May burn your tongue a little."

Fingering the cheese, her pale pink nails gently squeezed out the white sweat from it, one or two drops at a time. The outer corners of the woman's eyes were set far back at the sides of her face and she had a pale mole close to her right eye. Her

eyelids were redder and puffier than when she'd been under the parasol. She shifted her legs beneath her. The tatami gave a little creak. Her hand gripped something that for a moment looked like a fish that had been frozen solid: a kitchen knife.

"Let's divide it neatly in half, okay?"

To me that sounded like, Let's split the guilt, fifty percent for you, fifty for me. Without waiting for my reply, the point of the silver knife moved down through the warm air between the woman and me.

"*Formaggio al peperoncino*. My first time. You had it before?"

"Never," I whispered back, and the cheese, which was quite as flat as someone's tongue, was now neatly divided into two equal halves. Two shortish tongues sitting on a plate. We were about to eat purloined cheese. The two of us were about to swallow a cheese-flavored crime. I held back. And as I hesitated, I traced out the whole marvelous sequence of events. The Italian cheese from Kanekoya Supermarket was here in front of me, sliced in half. The woman who had shoplifted it and I, who had seen her do it, were now sitting here on either side of that cheese. What's next? I wondered, and took a gulp of water from my tumbler. The ice clinked loudly.

I heard another clinking sound. The woman's cheeks bulged with the water she had drunk. Like mine, her mouth must feel cool and clean.

Saeko stabbed the white tongue with her fork. The white thing floated in midair. Her own pink tongue stretched out to receive the white imitation one. White lay neatly on pink. Then pink with white on top retreated back inside. She started to talk.

"Ah, ish cood. Gold, but feelsh cood. Zlike habbing a nexdra dung. Wabba dry id?"

Her twin tongue moved up and down as she spoke. She stuck it out and waggled it from side to side to tempt me. Chuckling, I put the remaining piece of stolen cheese into my mouth.

"Iz drue! By dung's gold. Ooh, by dung's durning."

"Dad's beberonjino for oo. Id durns. Ahh, da sheeb's bilk's welly goo. Oo dry id. Zuck on za sheeb's milk."

"I dink zis sheeb's bilk's off."

"Iz theese, so whajja spect?"

The sheep's milk dissolved on our tongues. The red bits of the *peperoncino* stabbed and burned our papillae before the sweet rank curd sank into our smarting tongues and soothed them. Sitting there formally on our heels, we reveled in this cheese play.

"In da thop, du thaw, idn't oo? By—oo know—oo thaw id, wight?" Saeko inquired.

Du thaw, idn't oo? What the heck did that mean? So I stuck out my heavy tongue and had a go at repeating it. Yes, I thaw. Saw. The water. But I had never managed to figure it out. To me it had nothing to do with the rest of our private involvement. What was all that about?

"Yeth. I thaw. Oo ztole da theese. Zere wath a huddle of orter. Wha wa dat?"

Saeko repeated the word "orter" to herself in a nasal whisper. Meanwhile, she was shaking her head from side to side with such vigor I was worried her long neck might snap right off.

"Hease, hon't halk abow id. Hon't hell a'yone. Abow ha orter. Hon't hell awyone. Ah'm tho imbawassed."

In the course of all these aspirates, the woman gradually started to relax and loll forward, and the mouth with the tongue with the cheese on it moved toward mine, first across the low dining table and then, when that proved impossible, making a detour around it. Our private involvement had suddenly shifted

up a gear. The same taste and the same smell I had in my mouth came closer as I sat there straight-backed and formal, then the smells merged, and the divided *formaggio al peperoncino* was reunited, melting, disintegrating, filling our two mouths. The dry pine nuts rode on the wave of curdled milk that slid scratch-ily down my throat.

The woman clambered serenely on top of me. I choked on the warm curd and coughed beneath her. The woman floated up and sank back onto my lap as lightly as a feather futon, her movements matching my coughs. We both had white around the lips; were both still munching on what was left of the cheese. Still straddling me, Saeko threw herself back so her body was at a right angle to mine and breathed out in great gasps. Beneath her, I synchronized my breathing with hers. When I lifted my head, I could see the reflection of her magnificent white bottom in the dressing table mirror.

Through the white lace curtain hanging limply in the win-dow, I could make out the silver-gray sky above the laundry deck. If I stood up, I'd probably be able to see the ocean stretching out beneath the sky in a great magical expanse like millions of silver fish scales, shining brightly enough to blur the division between sea and sky even through the curtain. Behind Saeko was a win-dow at chest height on the wall my legs were pointing at. You could see the Kikoshi River and the red humpbacked bridge from it. My line of sight was blocked by one of Saeko's big ears.

I put out my hand and folded down her ear, allowing me to see a section of the sky above the river in the window frame. When I looked down again, I saw that the bare, bent knees of the woman astride me were digging into the tatami matting and her kneecaps had turned bright red with the effort of supporting her flailing upper body. I cupped and stroked her kneecaps with the

palms of my hands, gazing at her eyes as they switched between pale brown and dark brown in response to the changing light off the sea.

My loins felt warm and languorous. All sensation in my middle had just melted away as though I were soaking in a hip-bath. My nose detected a watery smell. I knew that one window overlooked the river and the other gave a view of the sea. The warm river water you could see from one window and the warm seawater visible from the other turned into twin seams of blue that rose up against the outside of the house and mingled and swelled here in this second-floor room. The warm water spread lazily across the tatami, drenching my buttocks and drenching the woman's bottom, and as it cooled a new surge would reach us, then drain back into the river and the sea when it had taken its pleasure with us. This was the scene that played itself out in ever-changing fragments on the inside of my eyelids.

For me, it felt as though I'd done something unforgivably self-indulgent, like taking a bath on a silk futon. And all this in the middle of the Multi-Month Campaign too, while my boss and the saleswomen were working their socks off knocking on doors, trying to make a sale.

A while passed and I heard something that seemed familiar. Every time the woman on top of me shuddered, a gurgling sound came from our pressed-together loins. When I shut my eyes, I saw a picture: a watercolor of just two shades, green and light blue, painted on the inside of my eyelids. A single narrow stream threaded its way across an enormous field. The blue line swelled and started to pour out of the picture frame, flooding my eye sockets.

Saeko's knees and thighs gripped me tight. When I opened my eyes, she was looking down at me with a wild gleam in her

eyes. She looked just the way she had when she stole the cheese. Muffled words came from her half-closed mouth.

"Aah . . . Downstairs. Downstairs. Granny downstairs . . ."

So there was someone downstairs! Just as I was starting to get my head around this, there was such a loud rushing sound that I thought my own eardrums were being flushed. At the same moment, I felt a flood of something washing over my crotch. But I wasn't startled enough by the noise and pressure of the liquid to push the woman off me and get to my feet. Maybe with all the signs of the buildup, I'd almost expected things to reach a critical point, burst and come pouring out. Besides, the stuff wasn't cold but at body temperature. No, it wasn't surprise that the sound and the pressure provoked, but a burst of pleasure that coursed through my whole body as I lay there on my back. After an interval, the sound of water returned a second and a third time; and each time I felt the warm flood surge over me, the space inside my eyelids turned a dazzling pale blue. The world, every inch of it, was swamped with warm water.

The water dwindled to a trickle and finally stopped. The curtain on the side of the room facing the sea flapped and I felt a gentle breeze on my cheek. The water the tatami hadn't been able to absorb fast enough made its way to my back where it stuck to my skin, getting colder and colder, before suddenly disappearing. My balls by now were freezing and started shriveling up.

Break

Maybe you think all this is just too far-fetched; that the whole story is as unbelievable as water suddenly spurting from between the printed words on the pages of this book and wetting your reading glasses. It wouldn't be surprising if you felt like that.

All I can do is repeat that *it's damn well true*, while trying not to be too insistent about it. There's no sense in debating it here and you'll probably never believe me anyway, so I feel a bit hopeless about the whole thing.

There are plenty of things in this world that are true even though no one knows or talks about them; but anything that people do talk about must genuinely exist. It's a yawn-inspiring cliché. On the whole, generalizations like this strike me as fundamentally dissatisfying, like the biography of some explorer who never found anything worth exploring in the first place. I'm not interested in enlisting generalizations like this on my side.

The sentiment needs some careful editing. *There are plenty of things in this world that are true even though no one knows or talks about them; but some things that people do talk about don't really exist either.* There are plenty of barefaced lies about. Lies are lies. Truth is truth.

It's the truths that are thought to be lies and the lies that are thought to be true which cause problems. The story I'm telling now belongs to the former category, but, believe me, it's not easy to tell a true story that's also totally incredible. Finding the right way to tell it is genuinely difficult. The louder the author's protests—*Honestly! I didn't make this up!*—the more suspicious the whole thing looks, and in the end no one believes him. If that's the way things are going to play out, then it makes more sense to keep the facts of what happened to yourself.

So, the only way I can respond to the criticism that this could never have happened is to sigh and say quietly, as if talking to myself, "No, it really did."

Anyway, let me get back to my story.

Telling Fortunes

The woman was leaning forward to peel an orange. I stole a glance at her face and was surprised to see her looking so cheerful.

"Bet that was a bit of a shock? Please don't tell anyone, okay? No one."

Who on earth would ever believe me if I did tell them? I didn't give her a clear yes or no, but shook my head in a non-committal way and went off on a slightly different tack about the *formaggio al peperoncino* we'd shared, before changing the subject completely by asking, "So your grandmother's downstairs?" She may have produced all that water, but I suddenly felt embarrassed about having played along and been so carried away by it all. Saeko pushed a piece of orange into my mouth as she replied.

"Yes, it's my granny. She's a professional Japanese confectionery maker. Or at least, used to be. She still does a bit of work here downstairs. She was asked by the people up at the shrine to make those paper slips with people's fortunes on them. She uses a proper brush. Works really slowly. Spends days and days writing out the things, from Supreme Good Fortune down to the Lowest Level of Luck. Then I take them off to the shrine."

Apparently, the old woman let the inspiration of the moment be her guide and produced everything from advice in categories like Sickness, Encounters, Business, Wishes, Directions and Moving House through to short poems. Saeko slipped another piece of fruit into my mouth. This one was fearfully bitter.

"Actually, it's not quite like that. She does write out fortune slips in the room down there—really puts her heart into it. But the bit about the shrine having asked her is some fantasy of hers. Alzheimer's. You know, gaga. I always end up chucking the slips

into the river . . . But one amazing thing is that, yes, okay she's a bit soft in the head, but she writes it all out nice and neatly, and every month she'll say, Here's your forecast, then give me my own special slip and more often than not it's bang on target.

"For several months I had a run of Ill Fortunes, but just recently I started getting good ones," she added with a giggle. Her eyelids were no longer red and puffy, and her face looked fresh, clear and beautiful. She lowered her voice. "I was worried the water might drip down to the room Granny's in . . ."

The bitter juice of the fruit slid down my throat. Maybe the water that had soaked into the tatami had threaded its way through the knotholes and cracks in the planks of the floor, slopped down from the beams in the hollow below to the ceiling of the room downstairs where it had formed a dark stain that spread out slowly on the ceiling like a map until it finally drip-drip-dripped onto the back of the old woman's gray head or onto the hand that held the brush. The idea seemed to worry Saeko a lot.

At this point, my obsession with sequences of events kicked in again. Cheese + Woman + Shoplifting → Earring → Me → Bridge + River → Parasol + Woman + Me → Humpbacked bridge → Cheese + Sex → Water → Granny → Then what? I wondered what was coming next.

"If the water did leak through, do you think your grandmother would mind?"

Under my bottom, and under the tatami mats beneath that bottom, I imagined someone looking from here like a stone in a dried-up riverbed, sitting with her neck screwed off to one side so she could get a good look at the ceiling. The result being . . . ?

"Dunno," answered Saeko. "This is the first time and she's a bit dotty. She probably wouldn't notice."

There was a pause in the unfurling of the chain of events. But something else was now bugging me.

"First time?"

"Yeah, the first time. With you is the first time anything crazy like this happened."

I felt a bit uneasy, as if I were being blamed and complimented at the same time. Had I really triggered it off? If yes was the answer, then I was a key figure in the whole thing. This was serious. I suddenly found the courage to ask about something that had been on my mind a while.

"But there was some water the time you stole the cheese at the supermarket, I'm sure of it. A puddle of it. Was that the same stuff as today?"

"It's really embarrassing but . . . yes, it was the same. But I swear, what happened here in this room has never ever happened before. This is the first time it's been so crazy, doing it with you. I can't believe it, that much coming out!"

Although I wasn't completely convinced, I didn't feel bad about it. I rearranged my crossed legs self-satisfiedly. Various mysteries still remained unexplained.

"And why did you pinch the cheese?"

Saeko clamped her mouth shut.

"Come on. Why? Tell me, if you can."

"The water . . . it's the water building up inside me . . ."

"You mean, when it builds up inside you, you steal things?"

"Uh-huh. When I know I'm doing something bad, something I shouldn't, that's when it comes out. Oh God, I'm so embarrassed!"

"But isn't that the result, not the cause, of your stealing things?"

"I told you already. I do it because the water builds up inside me . . . I'm sick. It's a horrible, weird disease."

It wasn't the shoplifting she was calling a disease, but the way the water built up inside her. The process went like this: water built up; she became desperate to get rid of it; the desire to be rid of it made her want to do something she felt ashamed of. Wanting to get rid of the water and wanting to do something shameful ought to have been separate like the roots of two different types of tree, but in Saeko's case those roots had got tangled together. When the "urge to spout water" root grew longer, it would pull the "urge to do something bad" root along with it; then her hand would stretch out with as little forethought as the tendrils of a vine and steal *formaggio al peperoncino*; she'd then feel mortified at the thought of what she'd done and the water would flow. That, I supposed, must be the order things happened in.

Even while I was busy assembling a mind-map of these different stages, it struck me as a shaky piece of reasoning. After all, the question of why the water built up—the first cause of it all—remained unanswered. But right then I was too excited by the result to care that much about the whys and wherefores of it. Who cared what the reason might be—all I wanted was to experience the same result a second time. The majority of people trip at this same hurdle. If they like the result of something, they get lazy about tracking down its cause, making it hard to re-create the desired effect.

Still, shoplifting is always wrong. I was emphatic about this with Saeko. You mustn't do it. You were darn lucky that I was the only person to see you. There's a porky lady by the name of Sumire Kawashima at that supermarket, her job is to arrest shoplifters, and she's on high alert for pigeon-toed women. In

fact, she's absolutely convinced that all the pigeon-toed women in the world are, without exception, shoplifters.

Saeko chewed her orange as she listened to me. Her cool, calm expression only made her more beautiful. The fruit was on its way down her pale slender neck. I could almost make out its color through her skin.

"I won't do it again. I never wanted to steal anything in the first place, anyway. I won't do it again. And who knows? If you stick around, maybe I won't need to . . ."

"If I stick around?"

"Yep. If you stick around to help empty all the water out of me . . ."

Ah, of course. Uh-huh, uh-huh, uh-huh. I nodded three times. And a vague agreement was thus established, whereby I had to "take care" of Saeko and pump every last drop of water out of her.

"But I'm telling you, I get so full. All the way to here."

Her eyes, which now looked as sad as a sick horse, opened wide as she fretted about whether I was up to the task. I promised I'd do my best. Placing her index finger across the uppermost part of her long neck, Saeko repeated: "I'm telling you, I fill up with water all the way up to here . . ."

Night

I left the house. I'd ended up with a contract to pump water instead of an insurance contract. I never did get to see the grandmother. Slipping through the garden wall, which was completely smothered in a trumpet vine, I found myself at the foot of the bridge.

Out of nowhere I thought of the *Aburatori* monster. Up in

the northeast in the countryside where I was born and raised people believed it came out in the twilight, though no one knew for sure what it looked like. If children kept on playing outside after night had fallen, then this monster would turn up from heaven knows where, wrap them in its arms and suck every ounce of fat out of their bodies. It had never actually happened to me, of course, but I could still recall the imagined sensation of warm black cloth enveloping me from behind. Here, I somehow felt that it was skimming just above the surface of the river with its fins spread wide like a manta ray.

It was a sticky night. Everything looked different. The humpbacked bridge was an arc that split the face of the evening, livid as a deep red wound. Under the bridge, where Saeko had told me earlier the water was brackish, the swirling river was the same deep indigo as the sky. I turned and looked back at Saeko's house. I gave a start as I saw the stippled orange of dozens of trumpet vine flowers I hadn't noticed before. It wasn't just the garden wall, the vine crept up the sides of the house as well.

As I started across the arched bridge, my shoes failed to produce the same nice crisp echo from the water they had on my way over, but made a dull, truncated, muffled sound. I stopped at the highest point of the bridge and looked down at the dark current. I caught my breath in surprise at the swollen waters that seemed to threaten the whole structure. I looked again at Saeko's house, feeling that she was gazing down at me from the second-floor window. I'm full of water, full of water, came a whisper from beneath the bridge.

As I made my way back along the street by the river, I felt as though I were paddling through lukewarm water. The frosted glass windows of the Kikujima Obstetrics and Gynecological Clinic had turned orange. The place looked as if it was on fire. A

long, thin shadow flitted to and fro on the far side of the orange. I went on a little, guessing from the murky, looming shadow of the willow tree that the Hanamura Iaijutsu Dojo couldn't be too far away. A heavy, moist smell came drifting over from my left to merge with the odor of Saeko's water. I flinched as I pictured the silvery glint of a sword blade in the shadow of the willow leaves, and felt the silent ferocity behind it. The afterimage of its tip was thrust into my back, and I picked up my pace.

No lights were on in the pet shop Saeko had popped into that afternoon, and there were bars across the entrance. The wet animal fug was thicker than it had been by day, the darkness tremulous with the sounds of animals nibbling and scuttling around. Through it all I managed to hear the sound of wings: wings being flapped in an attempt to fly. Those two bats—the Egyptian Russet Bats—were probably shaking their black capes.

The river close by was smothered in darkness. I knew the water had risen even though I couldn't see it.

The lights were still on in the barber's shop. The pole outside seemed to be rotating quite a bit faster than it had been in the daytime—so fast that the red, white and blue stripes merged into a single color. Several men and women in white coats stood clustered around a single barber's chair, each with a gleaming cutthroat razor in their hand. Their faces looked intent. One of the white-coated figures was bending over the barber's chair. The customer had blond hair. But no legs. It was a mannequin, torso only, with horrible red skin.

As I passed the bicycle shop, the shadowy figure of a fat woman passed me going in the opposite direction. The shadow had been hunched forward when it came toward me as if to shoulder its way through the darkness. There was a scowl in its eyes. I shuddered, thinking it might be Miss Kawashima, the

shoplifter-hunter, but I didn't turn around, only walked faster. Seeing another shadowy figure near the plastic model shop that looked like my office manager, I quickly looked away. Its head drooped wearily forward.

At the fruit shop at the corner of the First Bridge the lights were already out, and despite the heat they had the shutters closed up on the second floor, where they probably lived. I could hear different noises from under the bridge—the sound of water being churned up and splashed about. I could see some red carp half out of the water as they opened their nozzle-like mouths to suck greedily on the darkness. Muddy-smelling water splashed against the embankment wall. But the dark spray was not the work of the fish alone. The black men I'd seen earlier were up to their waists by the piers of the bridge, trying to catch fish by slapping their black hands on the water. The nervous owner of the fruit shop was probably peering through a crack in the second-floor shutters as the men disturbed the darkness.

I got to the bus stop in front of the fruit shop. I'd had a long journey. I felt as though I had swum down the river of memory all the way from the source to the mouth, then from the mouth back to the source in a single day. I was tired.

Bar Chart

Together with everyone else in the office, every morning I used to stand in front of a bar chart and sing the company song, listen to the broadcast of a pep talk by the guy in charge of the Multi-Month Campaign back at HQ, and sing my way loudly through the 5 Key Points of Salesmanship. You're probably raising a disapproving eyebrow at the thought, but the morning chorus, as we called it, whether the company song or "Home, Sweet Home,"

always made me feel pretty good. It was bracing, like a cool blast of fresh air.

We would all line up at 8:55. At 8:59, Suzuki, our boss, would turn on the special radio network that linked HQ with the one hundred and fifty branches around the country. And at 9:00 on the dot, a fervent-sounding voice announced "All together now, the Life Insurance song!" Immediately after this, the lead-in to a cheery karaoke track came booming out of the speakers. Then, eyes on the bar chart, we started singing.

> *Shoulder to shoulder*
> *With each and every man,*
> *Our aim is always bolder:*
> *To do the best we can.*
>
> *Tho' others may grow older*
> *And generations pass,*
> *Our hearts will get no colder,*
> *Our loyalty will last! . . .*

Both the words and the tune were by well-known people, but the philosophy behind it followed the standard school-song pattern, a sort of overblown optimism with gloom and doom pushed off somewhere in the background. But I didn't care. For me, it always brought back that sense of togetherness I'd experienced when we used to stand to attention and sing the school song right before the first match of the morning in the knockout stages of the summer high-school baseball tournament.

Not surprisingly, the saleswomen with their faces plastered with sunblock foundation sang so fervently that the walls would vibrate. There was a wonderful energy in their voices. Some of

them even got tearful at the line "Our loyalty will last!" I would feel a bit weepy myself and puff out my chest at the thought of the almost ten thousand men and women all standing in front of their own bar charts, all singing the same song at one and the same time throughout the length and breadth of Japan.

The campaign director's pep talk always ended with him telling us how many days were left before the deadline, our company anniversary. "Let's give it our best shot," he'd say, the voice emanating from behind the "Summary of Policies Sold" chart, so that the graph itself seemed to be doing the talking. We would all stare at the particular bar with our name underneath it, as if by doing so we could make it creep up higher.

The day I went to Saeko's house to have the cheese with her was fifty-two days before the firm's anniversary. At that point, I was trapped in a valley on the bar chart. I hadn't managed to sell even a single policy. "For you, this whole thing is more than fifty percent about training, so there's no need to bust a gut. Just as long as you can start building relationships . . . ," the boss had said to console me, but it still bothered me.

Fifty days to go. And sure enough, there I was still down in the valley. Forty-nine days. The saleswomen were putting up the fight of their lives. The sides of my valley grew steeper and steeper. I was at the bottom of a crevasse. As I did my rounds the sky was like a sheet of hot steel above my head. It was hopeless.

Forty-eight days to go, and once again I'd done nothing but loaf around all day. The phone was ringing when I got back to the apartment. It was Saeko. Her voice sounded stifled, as though something were stuck in her throat.

"The water's built up inside me . . ."

She asked me if I could come over right away. The water must be filling her all the way up her long neck to her chin. If

she made a sudden move, it might spill into the mouthpiece of the phone and come pouring out at my end. I wasn't forgetting my water-pumping contract; it was just that I'd been a little busy. I shot out of my apartment. My own Multi-Month Campaign had now got under way in earnest.

Aquarium

"Did you notice the trumpet vine? Wonder if it's because I didn't prune it in the winter. It's growing like crazy all over the wall and up the sides of the house. Not one of my favorite flowers."

"It was too dark. And I was in a hurry to get here . . ."

"I've got to tell you what the last fortune slip Granny made for me said. It wasn't just a routine one—more like her really reading my future."

"So what did it say?"

"'When the wind starts to blow on the calm-looking sea, then the little boat is in danger from the wild, wild waves.'"

"Sounds like bad luck to me."

"It was the Lowest Level of Good Luck, actually. 'Something Lost' was 'Hard to Find'; I should 'Put off' 'Moving House'; 'Sickness' would 'Get Better Over Time'; 'The Person You're Waiting for' was 'He Will Eventually Come, Despite Difficulties.' That's why this forecast's still in the lucky camp. I mean, you turned up like this for me, didn't you? You made my 'Wish' come true."

"And what did it say about your 'Wish'?"

"That it'd come true."

This was all the conversation we could manage before we began to pump water again. The first time, we'd eaten the cheese mainly to cover a certain embarrassment, and now a chat was the only available option as a lead-in to the second round. The futon

was already spread out on the floor. There was a big tarpaulin on top of the bedding, with a further two bath towels on top of that. It was clear from the expression on Saeko's face that she couldn't wait a moment longer. She turned off the light and moaned.

"Now, make my Wish come true."

Saeko was straddling me. There was a patch of bluish shadow in the hollow between her collarbone and her long neck. I assumed water was building up in there. Her ears went red and white like signal lights. All the signs of clear and present danger. When I stroked her ears, she softly let out her first gush of warm water. I couldn't help murmuring, "So soon! Amazing!" and Saeko, who was panting away on top of me, relaxed for a moment, giggled and released another gush of water. "Talk about—uh—amazing—what about you?" She gasped out the words and her body spasmed again and the water came, then kept on coming in a languid, endless stream. I felt as though someone was stroking my groin with warm velvet. The water was body temperature.

Water at body temperature. Like the warmth of blood.

I'd read about it in a book somewhere. If you had pints of blood fresh from someone else's body poured on your head, you wouldn't actually feel anything for a second or two because the blood would be the same temperature as you. It was the same with Saeko's water. Even when there was a lot of it, the sensation it gave was so faint that the word "sensation" seemed like an exaggeration. If I let my mind wander, I could miss it completely. It was a warm pressure. Ever so slight. A pressure without any tactile sensation. Or a sensation without any pressure, perhaps? When it came to what was going on in my crotch area, in the end I had to rely mostly on my imagination. At least until the water got cold.

Its quality and composition probably had something to do with it, I thought, as I lay there beneath her. It wouldn't have felt the same if I'd been soused with a mineral water like Evian instead, heated to the temperature of Saeko's liquid. I wouldn't even need to look to know. It'd be like, What's going on here? This is Evian! And tap water would be completely useless—don't even think about it. Just too rough. Unless Saeko drank it, broke it down and filtered it to get rid of all unwanted elements, there was no water in the world that was capable of turning into this tepid, top-notch stuff. Such was my conclusion.

More and more of it was pouring out of her. My scrotum was swollen like a lily tuber growing in water culture. Emotion swelled inside me. More and more water came flooding out. I had turned into that "little boat in danger from the wild, wild waves." I laughed at the phrase. I laughed as I pumped my loins. The water surged over my tuberous testicles in a flash flood. More water than ever. The two towels didn't stand a chance of soaking up all the liquid that flowed from my buttocks up to my back, washing over me in such an endless stream that I wondered where this last surge could possibly be coming from. My balls had been squashed into ovals like a pair of baby octopi dragged along by a powerful current.

Not just the sound; the smell of the warm water clogged the whole room. It was difficult to breathe. The window overlooking the Kikoshi was damp and slimy. We could have been mating on the floor of a dimly lit aquarium. An aquarium where the tropical fish tanks had cracked and were leaking onto the floor. There *was* a cracking sound. The tank *was* about to burst! I'd probably be swept out of the window and into the river like a fish in a millrace. Saeko lifted her long neck. She raised it to the vertical like a periscope, stretching it beyond its natural limits. When her neck had gone

as far as it could, there was a sound as if someone had suddenly opened the water main all the way. Such a torrent came out that I could easily have been swept away. I pictured myself being sucked headfirst down into swirling waters. In all the excitement, my tuberous balls detonated prematurely below the waterline.

Hydrotoxia

I floated lazily in a warm puddle. I was as happy as an otter. Saeko was still venting the last of her water in thin trickles. The sound was like the treble part of a piece of repetitive piano music that was being wafted here from ten kilometers away. Then came the *ritardando*. It slowly faded to silence.

"Do you think there's less now?"

Saeko's voice was hoarse. Was it just my imagination, or was that thin neck of hers even thinner? Had her earlobes really become flimsier and flatter? My answer was another question.

"Have you ever discussed this with a doctor or anyone? The water thing, I mean."

"Yes. First, I went to my local doctor. An old fellow. He seemed reliable enough."

"And what did he tell you?"

"It was weird. He said he suspected it was some kind of hydrotoxia."

"Hydrotoxia?"

"Uh-huh. It's a condition where a buildup of water inside the body makes you feel light-headed and anxious. The cause is usually 'an adrenal crisis or a decline in secretions of the antidiuretic hormone.' Something wrong with the 'anterior pituitary function,' in other words. He thought I was producing this much water because of a 'decline in hormone secretions from the

anterior pituitary.' If you have that, you can produce more than seven liters in a single day, he said."

I was listening, but nothing she was saying really registered. It was as though someone had found a powerful poem on the subject of water and cut it up to weigh and measure all the individual words, mixing them with chemicals in a test tube to analyze the secret of their power. Only the term "hydrotoxia" lingered in my ears.

"I couldn't really figure out what he was talking about, so I went to see a young doctor at the Mutual Aid Clinic to ask him if the local guy was right."

"And?"

"And he just laughed at me. 'Ha-ha-ha, it's nothing to do with the anterior lobe. The antidiuretic hormone, my dear lady, has no relation with the anterior lobe whatsoever. Ha-ha-ha. A rudimentary mistake. It's the posterior lobe. The posterior pituitary lobe does the secreting. The abnormality is in your posterior lobe. Honestly, these local doctors are so hopeless.' He sort of lumped me and the old doctor's diagnosis together and laughed at us both. Sniggering and sneering. I started to feel sorry for the poor old doctor—actually wanted to believe that the secretions *were* coming from the anterior pituitary lobe."

So did I.

"What about treating it?"

I had asked the sixty-four-million-dollar question.

"He told me to take Desmopressin Acetate nose drops. It was really uncomfortable. There were these two tubes sticking out of the bottle. One of them you stick up your nose and the other you put in your mouth, and you blow the medicine up into your nose. I was very serious about it. I was prepared to put up with torture if it'd help me get better."

I couldn't bear the thought of two tubes stuck into that beautiful face of hers.

"You poor girl . . . And did it work?"

"Not a chance. You see, one day I suddenly realized that the old doctor and the horrid younger one had both made the same mistake. That . . . uhm . . ."

Saeko's face darkened like the sea at sunset and her voice was almost inaudible. Her white neck quivered. Outside the window a siren wailed in short, faint bursts probably quite some way upriver. Now I could see just how much suffering Saeko's problem had caused her. She took a deep breath, then, with a hint of recklessness, went on.

"The thing is . . . this water I'm so desperate to get cured of . . . they'd both assumed it was pee. Probably my explanation wasn't any good. How was I expected to go into detail? I would have died of embarrassment."

She couldn't bring herself to tell them that it was what's called love juice; or that it came out two liters at a time. The upshot was an incorrect diagnosis and her being made to take nose drops for diabetes insipidus.

It was an inexcusable mistake. As bad as confusing amniotic fluid with corrosive yellow acid. I didn't interrupt her, but I felt as furious as if I were the one who'd been misdiagnosed. I didn't really see why I should be so angry, but it seemed just as outrageous a mistake as being accused of a crime you didn't commit. I was so angry, in fact, that I failed to notice that I was discriminating unfairly against urine—against perfectly innocent pee.

Saeko continued with her explanation.

Later, she had managed to screw up the courage to provide a more specific account of what was happening to her, but no one

apart from her not-yet-gaga granny had believed her. One doctor claimed that the thing was an impossibility, both clinically and theoretically; that it was about as plausible a story as a squadron of elephants flying through the sky. She had also tried to discuss it with other women in a roundabout kind of way, pretending to be talking about someone else's problem. The reaction was always the same: "Look, I produce a certain amount of juice too, you know, but with that person, it's just got to be pee. There's no other way to explain the quantity." To her dismay, she found that women were actually worse than men when it came to rushing to judgment about it.

Her anguish over this must have made her feel like some still-unnamed bird, one featured in none of the world's field guides or animal classification dictionaries. As I thought about it, I gently stroked her ears. They were as cold as *kuzumochi*. God only knows how many nameless, undiscovered and unclassified forms of pain there are in this world of ours. I kept rubbing her ears until they warmed up.

"In the end, the only option I had was to cure myself. I made up my mind. I hated shoplifting. I was desperate to stop. I thought long and hard and I came up with the idea of cutting the water off at its source."

So Saeko had restricted her intake of water. She had stopped drinking the coffee and green tea she liked so much. In a few days, she'd lost so much weight she felt light-headed.

"I knew if I stuck it out, I would die. Suicide through dehydration. Drying up like an old sardine. I really thought I could pull it off."

But Saeko didn't manage to get that far. She'd had to do some grocery shopping for her grandmother and had collapsed in the street and been carted off to the hospital. She was diagnosed with

a serious case of hypertonic dehydration and put on a drip for a whole week. She'd blown her chance of committing suicide through water deprivation. She confessed that even after cutting her water intake right down, she had still felt the liquid accumulating inside her, albeit in small quantities; that it had made her want to shoplift; and that some had still come out of her, though not a lot.

Having told me all this, Saeko slid open the closet and dragged out an enormous brown Boston bag. She unzipped it slowly.

"Souvenirs of my shame. Look at them all! Look!"

She took the things out of the bag one by one and arranged them in neat lines on the sodden tatami.

Five different toothbrushes. Three tubes of toothpaste. Two stainless-steel spoons, one big, one small. Two small bottles of Tabasco. A small wooden pestle. Two cheap lighters. Two books, *The Travel Guidebook of India* and *The Travel Guidebook of France*. Loads of small paperbacks including the Kodansha edition of J. Patterson's *Midnight Club* and a Shinchosha *Replay* by Ken Grimwood. Two bottles of Japanese perfume. One cheap, tacky ring. One fruit knife. One single-use camera. One packet of nonpyrine system cold medicine. Digital watches—too many to count. A nicotine pipe to help with quitting smoking, Johnson & Johnson Q-tips, pincers, key rings, combs, Calorie Mate, ear picks . . . As she plucked the items out of the bag one after another and laid them on the floor, she reminded me of the proprietor of a bankrupt five-and-dime store. When there wasn't enough room left for me to stand, I went and sat on the window ledge.

"That's enough," I said sternly. After a while, Saeko, who was down on her hands and knees, looked up at me. Tears were glinting in her eyes. Despite the large amount she'd just released, she still had some water left to cry with. She had her finger just beneath her chin.

"These are all the things I stole when the water was up to here and was almost spilling out and I was going crazy . . . But since we ate that cheese together, it doesn't come up so high anymore. Doing a lot of shoplifting meant I could get rid of the water bit by bit and more or less get by okay . . . Up until I met you at that supermarket."

So there had been hundreds of other puddles before the puddle at Kanekoya. I sighed deeply. The sigh was so deep that it surprised even me. It wasn't one of disappointment or distaste, but a sigh of sympathy and admiration. Above all, it came from a sense of wonder—at all the intersecting events that had drawn me in to be a witness of this.

Various scenes, all of them framed like the speech bubbles in comics, flitted past my mind's eye. The backgrounds were different, but without exception they featured puddles, more of them than you could count. A puddle in front of a tobacconist. A puddle by the newspaper rack in a newsagent's. A puddle glimmering discreetly in a dim hardware store. A puddle people had stepped in on the floor of a bookshop. A puddle just starting to evaporate by the wall of a toy shop. Abandoned by their maker, their provenance and nature a matter of universal indifference, this multitude of little pools coalesced in my mind, where they shone with a dull rainbow sheen. And among these commonplace things—the countless blue spots on the earth devoid of meaning and doomed to quiet evaporation, some at least must be pools of sorrow, like Saeko's. How could we just glance at them with such in difference? The thought came as a shock to me.

Saeko had started speaking again. Her voice was tearful.

"One day I told Granny everything. About the water and the stealing. Granny was still normal back then—she was teaching

me how to make Japanese sweets . . . She listened without saying a word, but crying the whole time. Then she hugged me. 'Saeko, you've got to stop that stealing. You need a man to make love to you and pump your water out. Find yourself a good man who's willing to pump it out of you whenever it starts building up.' Easier said than done, that. I just kept right on shoplifting. Then I bumped into you at Kanekoya. When you gave me back my earring I looked into your eyes and thought, 'Ah, this is the man.'"

She'd been wondering whether to call the number on my business card before spotting me on the bridge.

"I haven't pinched a single thing since the day we had the *formaggio al peperoncino* and you pumped me dry." She spoke with obvious pride. "All thanks to you," she whispered, pressing up against me again. I felt a strength within me like the sea at full tide.

"You are my one and only key. The key that unlocks my water gate," she added by way of emphasis.

Daruma

It was around then that the organizers of the Multi-Month Campaign sent a victory Daruma doll to our sales office. I suppose it was because we had already achieved almost half the quota we'd been allotted for the campaign. I still hadn't managed to sell a single policy myself; I was too busy waging another campaign. My boss, though, was in the best of spirits because the first half of the project had been a bigger success than anticipated. He wasn't going to kick up a fuss about a bumbler like me.

The one-eyed Daruma was placed next to the chart. This was on the day with forty-one still to go before the company anniversary. Standing there in front of the doll and the bar chart

every morning, the salespeople and I sang the company song and vowed that victory would be ours. I could feel the strength pulsing through my body. I would leave the office with a cheerful "See you all later" and, after making a halfhearted pitch to a couple of houses in the eastern district, I'd wander down along the river and cross the red humpbacked bridge to Saeko's place, where I'd perform my water-pumping duties. It wasn't a bad way to spend the day. I started to develop a sense of responsibility, like the man in charge of a reservoir.

Fireworks

It was the day of the summer fireworks display. There was a new moon and the tide was high. I strolled along the embankment keeping an eye on the Kikoshi River, which was quietly rising, and once again crossed the humpbacked bridge.

"Granny's gone down to the beach to watch," Saeko informed me, though I hadn't asked. Dressed in a *yukata* with a bellflower pattern, she took me by the hand and led me out onto the laundry deck. The fireworks were going to be launched from some fishing boats moored offshore.

The planks of the laundry deck creaked. As the roof of the next-door house was in the way, you couldn't see the beach, but several of the boats' lanterns were visible above the neighbor's roof, with the black sky lowering behind them. Saeko vanished downstairs, leaving me alone out there. The first fireworks went up with a bang while she was gone. She soon returned carrying a tray with some dishes on it. I couldn't see her face clearly and had no idea what was on the plates.

A firework burst into flower. A little light fell on whatever was on the tray, and I caught a glimpse of something purple and

transparent. You could see straight through to the floral design on the plate, though it was a little out of focus.

"Looks like a jellyfish," I whispered.

Saeko gave a little giggle. "They're see-through *kuzu kiri* noodles. The other plate's molasses," she said. "But it didn't actually come out very well." The business of dissolving the arrowroot starch in water and pouring it into a cooking tray floating in a pan of hot water had gone fine, but for some reason she'd messed up the bit where you submerge the tray in the water, and had ended up with mild burns on her index and middle fingers.

"I just couldn't wait!"

She lay down on the deck as she said this.

"Holding a kitchen knife is painful when you've got burns, so it's not very elegantly sliced. It's in horrid great slabs."

When I climbed on top of her, the deck shuddered and creaked, and the lanterns on the fishing vessels swung back and forth, drawing yellow lines across the night sky. Saeko's hand swam off to one side and she picked up some *kuzukiri*, not bothering to use chopsticks. Peering at the semitransparent membranes sticking to her fingers in the darkness, she said, "Looks just like a dead jellyfish, doesn't it?" She dipped this quivering flabbiness into the molasses, then slipped half into my mouth and half into hers. The two of us chewed the sweet and unresisting stuff as though we were eating the darkness. Another firework burst.

With the *kuzukiri* in her mouth, Saeko released a gout of water. This swept across the rotten planks, washed over the flowers and tendrils of the trumpet vine that had crawled to the base of the laundry deck, and dripped down onto the corrugated iron roof below with a sound like the patter of raindrops. Though I couldn't actually see it, I knew what happened next. The warm

liquid flowed down the furrows of the corrugated iron, slid over the earth, threaded its way through cracks in the stones, then slithered down the concrete wall and into the brackish section of the Kikoshi River. The dark river bulged and bristled like a wild animal.

I lay there on the laundry deck with my arms and legs flung wide and pondered. I was the key! The key to the water gate! Wasn't that great? I'd never been picked for so important a task before. Better still, my sense of duty and the pleasure involved were in perfect sync. It was wonderful! A series of fireworks burst into blossom in the sky. I thrust upward in response to the din and Saeko produced a whoosh of water. Now *I* was a jelly-fish, floating on the warm membrane of the sky or the sea or the river—which of them, I didn't know.

The firework display ended.

I was in the middle of the red bridge when I saw a gray-haired old lady struggling toward me. In her old-fashioned clothes she was bent double, but despite the darkness I could see how unusually long her neck was. Her wide white-looking ears were also like Saeko's. I stopped in my tracks. So did the old woman. A version of Saeko's face just that little bit smaller than the real thing peered at me intently. The darkness smoothed her wrinkles. She mumbled something as if chewing on a straw, bowed slowly and deeply at me, then moved on. "Thank you for taking care of Saeko's water problem." At least, I think that's what she said. Standing in the middle of the red bridge, I bowed deeply at the old woman's retreating back.

"You can rely on me," I told her.

Break

I have a friend who likes hunting down cut-price air tickets and flying off to Asia and Africa. He's a nice guy and I like him a lot, but he does tend to be a know-all and lecture people on everything. This is what he had to say.

"It depends where you go, of course, but generally that sort of wetness isn't appealing at all. Traditionally it's never been popular. And personally, I don't like too much of the stuff myself, either."

Then he produced a series of examples, one from a town in Indonesia and another from somewhere I'd never heard of in northern Vietnam. He described how people in these places would respond to any sort of heavy secretion with "as much horror and alarm as if it were the devil's saliva," and that the women would squat down in a panic and wipe themselves clean. "That's their etiquette, you see. I believe we used to have the same sort of civilized custom in Japan too," he added.

Taking care not to mention Saeko directly, I tried to probe every possible angle. As a result, one thing became clear. Although my friend was using the word "wetness," he was reckoning from a low of around thirty to a high of around two hundred milliliters. I didn't know what to say. I'd been talking about two-liter units of the stuff! Cultural questions like "to wipe or not to wipe" didn't apply at all.

Why's this guy so obsessed with volume, you may be thinking. Well, you're probably right. I'd like to be able to take a more philosophical, big-picture point of view myself. I'd like to, but then imagine: (1) three stars winking feebly in the sky (2) three thousand brightly burning stars covering the whole canopy. When things are this different, being detached and philosophical is

simply out of the question. Size and quantity have something about them that tears any logic-based argument to shreds, no matter how clever it may be. Then there's the question of taste. The more water the better, I say. But I can't very well shout it at the top of my voice: "THE MORE, THE BETTER." I mean women with less than two liters in them, and their partners, make up the world's overwhelming majority. So I'll say it under my breath.

I like . . . a lot of it. Really I do.

I've got off the subject. I should push on with the story.

Gray Mullet

One day I saw a school of gray mullet.

It was a sunny June afternoon and, aside from a slight feeling of fatigue, I felt almost obscenely energetic. I took my time over a beef patty lunch at the Jonathan's family restaurant near the station, then boarded a bus. There I bumped into Yuriko Yoshimura, one of the people from the office. She was a middle-aged woman who sang the company song every morning in an operatic voice and whose bar chart was rocketing vertically up. Catching sight of me, she smiled, her face like a marigold. "How's it going?" we greeted each other heartily. I got off at the First Bridge. In a voice quavering with energy, she called after me: "Give it all you've got!"

Despite the heat, the shops along the river were uncharacteristically lively. The barber's pole was spinning around with great verve, and the animals in the pet shop were barking and howling enthusiastically toward the river, although, as usual, there was no sign of the owner or any customers. "Hoh! Hoh!" resonated from the Hanamura Iaijustu Dojo, as the students

opened and closed their diaphragms with ritual shouts. Babies crying made the windows of the Kikujima Clinic rattle. The river itself flowed happily along. Like the night before, I was conscious of the brackish water beneath me as I crossed the last bridge.

On the deck, the futon had been hung out to dry with the sheet still on top of it. If I screwed up my eyes, I could make out a large stain shaped like Madagascar on the sheet: Saeko's water from last night. Madagascar absorbed the July sun, flapping gently as it sent a delicate trail of steam into the quartz-clear sky. My eyes followed this up to a bright cluster of marshmallow clouds. Saeko's water was turning into steam, and the steam was turning into clouds. The marshmallows were growing plumper and plumper, the futon and the sky above it credible evidence of the connection.

The trumpet vine, too, was moving stealthily upward. Its arms had reached up from beneath the laundry deck and now, even as I watched, new pale shoots were emerging from the tips of its dark green fingers and curling around the handrail. The orange, five-petaled flowers blanketed Saeko's house, their heads competing like a choir of sopranos. I stood and stared in wonder. When I turned away, the reflection off the river was so bright it hurt my eyes.

The whole scene was just like a full-color illustration of the water cycle. Precipitation—Accumulation—Evaporation—Precipitation. It brought home to me the vigor of that endless cycle. And what it also showed was that I played an important (though not, admittedly, *the* most important) part in that robust, unending process. There was something deeply satisfying in the thought.

"Hey, do you want to go down to the waterfront? See the sea? I have my own secret place there. I'll show you," said Saeko. She had on a white linen dress.

After strolling along the street by the river awhile, we came out onto the coast road, where we turned east. We walked and walked on the hot asphalt, she pigeon-toed, I splayfooted. Somewhere along the line the heat haze made our legs melt like so much candy, and splayfeet and pigeon toes were all much of a muchness. A silver, cigar-shaped blimp slid across the sky above.

The sea was flat, as if the wrinkles had all been ironed out of it. During the roughly five-hundred-meter walk to the yacht harbor, she told me about her father, a handsome man who had left his family for another woman. Over the one-kilometer stretch between the harbor and a fishing tackle shop, she told me the sad story of her mother, who had died in a botched operation for thyroid cancer. I held her hand tight. The ocean glittered on our right. A stranger might have thought that Saeko was just discussing the food at some seafront restaurant—a shrimp casserole, perhaps—since she kept her long neck perfectly straight and didn't cry. As we turned at the corner with the fishing tackle shop and began to make our way down a little plank path, she mentioned the life insurance her father had taken out for her mother. The policy wasn't from my company, but it was reassuring to hear that the payout had been a generous one and the money had gone directly to Saeko. The smell of saltwater grew stronger. In front of us, a small but perfectly formed cove lay gleaming like a turquoise-blue mirror.

The beach was empty except for a couple, younger than us, who were sitting facing each other. It was quiet. The man and woman gazed into one another's eyes and talked in sign language. Up in the sky was the silver blimp. Saeko pointed, "It's over there." At the tip of her finger the curve of the inlet came to an abrupt end and a concrete breakwater stretched out into the

sea. There were concrete tetrapods like a dead dinosaur's teeth protecting it on both sides.

Saeko took off her sandals, climbed down off the breakwater and onto a tetrapod and started to ease her way in between the jagged edges of a molar and an incisor. Her legs disappeared; her torso disappeared; her long neck disappeared; and finally she herself disappeared entirely into the shadow below. There was no line of sight into Saeko's hideaway. "I'm down here," came a muffled voice from somewhere under my feet. The randomly heaped-up concrete blocks had created a triangular space like a hollow pyramid and Saeko was crouching on its floor, her lanky body bent into a C. There was a dead starfish just by her bare toes. A crab and a wharf roach were scuttling about in the space between her feet and the blue sea.

"I must've come to this cave fifty times since I lost my mum and dad. No one can see me when I'm in here; but I can just *look*. I turn into an eye, and 'me' sort of disappears."

I crouched down next to her. When seen through the triangular concrete frame, the tanker on the horizon and the yacht offshore and the couple speaking in sign language all looked like photographs cut out of a book. We'd been buried in a stone graveyard, us and the dried-up starfish, forgotten by the world. Reduced to four eyes, Saeko and I stared at the bubbles on the sea and at a seagull in the far distance.

"Empty me, please," Saeko asked, without taking her eyes off the sea.

Every so often we'd bump our shoulders and heads against the concrete. In the cramped cave our intercourse was inventive as we formed ourselves into different shapes—a sideways H, an N, a V, a W, a Y and a K. Saeko's water splashed onto the dead starfish. Its vivid orange color returned. Her water ran between

the parched stones. From outside, it must have looked as though the dinosaur was dribbling between its enormous teeth.

"Every last drop!"

It felt strange to hear her say this when there was an inexhaustible supply of seawater so close by, but I still did my best. Her water trickled out from the tetrapods into the sea. The fact that, though a small flood when considered in isolation, Saeko's water didn't amount to a seagull's tears when poured into the sea may have been obvious, but I was only too aware of it. Nonetheless, Saeko was by no means prepared to let the sea prevail. She kept on spouting and spouting in a stream that showed no sign of stopping. In the end, we fell into a doze, lying in the shape of the letter B in the cramped, pyramid-shaped cave. As I drifted off, I was thinking *I plug myself into Saeko; Saeko spouts out water; the water drains into the sea; and then the sea . . .* I loved Saeko and I loved her spouting.

When I woke up, a thin film of seawater a good deal colder than the other kind had started washing over the floor of the cave. The tide was coming in. The waves were slapping loudly against the outside of the cave. "Mullet! Thousands of them!" yelled Saeko.

A swarm of mullet covered the sea like a well-laid wall-to-wall carpet. The sea was boiling and bursting with them. You could have walked all the way out to the yacht offshore on their gray-blue backs, there were so many of them. Some leaped up to expose silver underbellies that looked like throwing knives in mid-flight before slicing their way back into the sea.

The sign-language couple wasn't there anymore. There were more marshmallows in the sky than before, and shadows dappled the mullet-filled sea. As we crouched in the tetrapod cave, there was no one there but us to contemplate the sea of mullet.

We could have caught the fish forced out of the water up against the concrete blocks with our bare hands.

"See their eyes? That's the difference between gray and redlip mullet . . ."

Saeko was speaking loudly. But I wasn't listening, I was busy thinking: how I plugged myself into Saeko; Saeko spouted out water; that water drained into the sea; the sea attracted the mullet; and the mullet . . .

"See their dopey-looking eyes? That fatty bit they've got's called an adipose eyelid. Well, the redlips don't have it. My granny taught me that."

A kite flew out from the direction of the fishing tackle shop. The mullet attracted the kite, I thought, and the kite . . . The bird's shadow fell on the sea. All at once, the whole mass of fish turned tail and dived, sending up plumes of water across the sea as if a barrage of shells had landed, and turning the air above into a blur of white.

"You know, the baby mullet swim up the Kikoshi in springtime, all the way to the red bridge."

I'm ready to believe anything, I thought as I looked out at enough mullet to make the whole ocean stink of fish. If a massive El Niño occurred in Sagami Bay, I'd probably put it down to Saeko's water. If the friction between the seawater and the earth revolving on its axis made any noise, I'd probably be able to pick it up, as my ears were fine-tuned by now to another watery sound.

It was a fantastic day!

Everything was going so well between Saeko and me, the one man who could make her spout.

Pepe

A few days after we'd seen the sea full of mullet, my mother out in the country was hospitalized with chronic renal failure. I got a tearful phone call from my sister saying that the doctors only gave her a fifty-fifty chance of survival as she was in the tertiary stage of the disease. My boss, Suzuki, gave me time off and I caught the first train home the next morning, more worried about Saeko than the Multi-Month Campaign. In the upshot, dialysis proved more effective than expected and my mother showed a slight improvement, but six days had still slipped by. On my return, I immediately went to see Saeko. I had water on the brain.

She was thrilled to see me and responded in her usual way. But I was suspicious even as the water washed over me and I watched it form puddles on the tarpaulin over the sheet. Is this really six days' worth of water, I asked. Sure, there was plenty of the stuff, but it wasn't a conclusive amount. What was going on? We had our first row. I interrogated Saeko sharply, as the man in charge of a reservoir from which water has gone missing might feel obliged to do, but Saeko held her long neck high and defended herself.

"Do you think my body's some kind of feeding bottle with measurement markings on it? And shouldn't you be pleased if there's less water than before, anyway? I want to produce less of the stuff, or stop completely, if I can."

The way she spoke made it clear that the sooner this problem could be sorted out the better, but I was only interested in the question of how. As far as I was concerned, the problem was this: Had she used proper or improper means when venting her water? (It sounded like the silly sort of question some fatheaded police-man might ask.) If she had vented her water when I, the official

key to the water gate and the sole legitimate and proper means to achieve said venting, was absent, then it was only reasonable to conclude that she must have used improper means. But she wasn't going to let a stupid question like this provoke her.

"It just happened. There's less of it and I'm pleased."

A natural reduction. An innocuous enough response. I changed tack. I took a deep breath and started to quietly sermonize. Listen, I'm more than just any old key to the water gate. I'm a key that can think for itself. Yes, I can do that now. What I mean is, I'm quite an expert when it comes to water. I've got to the point when I can tell instinctively if there's more or less of it.

It was an earnest sermon. Saeko's neck bent like a silver birch in the wind. Her brown eyes brimmed with tears.

"I'm sorry. I couldn't—I just couldn't stand it anymore. I'll never do it again. Please, say you'll forgive me."

At the sound of her tearful voice I started to freeze like a forest lake in mid-winter; a lake so cold that a single tree leaf landing on its surface might freeze it all rock solid.

A man?

Had someone else crossed the red humpbacked bridge? I buried my head in my hands. Saeko was crying as she tore back the curtains and slid open the window that faced the sea. "Look at that!" she cried.

There was a birdcage on the laundry deck. Inside was something that looked like a screwed-up brown handkerchief. A bat. A single bat hung there upside down, its blackish-brown eyes fixed on us both. Damned if it wasn't the Egyptian Russet Bat from the pet shop on the river!

"Planning to keep it as a pet, are you?" I asked. I was shocked, but also relieved that the male in question was not human.

"The truth is . . . I stole it. Just half the pair. Four days after you'd gone, it was horrible, I had water up to here—"

Crying harder, as though she expected this would get her sympathy, Saeko placed her index finger just beneath her chin. A new feeling of anger and pity welled up in my throat. I could picture the scene with the puddle in my mind's eye.

Her body brimful of water, Saeko makes her pigeon-toed way into the dark interior of the pet shop. The owner is taking a nap. Saeko looks at the bats' cage with the glazed eyes of a drunk. A pale hand opens the cage door and reaches in for one of the animals. She grabs the warm body enfolded in its cape. The bat tries to resist by wrapping its little toes around the wire mesh. She pulls it off. The one left in the cage flaps its cloak in limp and mournful farewell. She casually puts the stolen bat into her bag, just as she did with the cheese. Uh-ah. A moan. The warm water spurts out of her. It runs out of her panties, down her legs, over her shoes and onto the dirt floor where it forms a puddle in a dark dip. Seeing how horny she looks and the water streaming out of her, the sensitive marmosets yell shrill encouragement at her. Saeko comes to herself. She dashes out of the shop, water splashing from her heels. She leaves a puddle in the gloom with its animal stench. The water glistens like oil . . .

"What the hell are you going to do this time?" I asked her. "You can't very well cut it in half and eat it like the cheese, can you?"

"I'm going to keep him. Look after him. He's so cute. The poor little thing was frightened out of his wits when I took him out of the bag, and he went and wet himself. His pink willy was tiny—smaller than a tiny berry. There were pretty little drops of pee like little diamonds sticking to the fur on his chest. I just felt so sorry for him."

Saeko wiped away her tears as she spoke.

A live bat was about to become part of her trove of stolen things, kept as a secret record of her shame.

Now that she pointed it out, I noticed that the Egyptian Russet Bat did have a cute little face like a miniature just-born baby donkey. It even looked slightly distinguished. Its round, wide-open eyes were irresistible, while its nostrils stuck straight out as unaffectedly as the snout of a pig. I could see no evidence of that evil reputation that clings to these mammals.

Twisting my head till it was upside-down, I looked at the upside-down bat and pondered.

Everything that goes around comes around. It wasn't that long ago that it had passed through the hands of a number of dealers, then been shipped by boat or plane from somewhere in North Africa or the Arabian Peninsula all the way over to Japan. In its previous life, it had probably spent its nights flying gracefully around the Great Pyramid of Giza with its wife or girlfriend or whatever. The two of them had been caught in the net of a swarthy Middle Easterner with a moustache. Dispatched to a rich Far Eastern country where the people are prepared to turn anything into a pet, they'd been lumped together with animals that had nothing at all to do with pyramids, then sold wholesale, still as a pair, to a pet shop by the Kikoshi River where they waited for a buyer. Then, out of the blue, one of them had been kidnapped by a Japanese woman who was driven to shoplift by the pressure of water inside her, put into a birdcage, and now found itself on a laundry deck with the wide expanse of the nighttime Pacific for a background. Everything that goes around comes around.

The reason Saeko had done it was because I—her friend— had gone away for six days. In other words, if my mother hadn't been hospitalized with kidney failure, then this particular Egyptian Russet Bat (which may have flown around the pyramids in

its time) would not be hanging there looking at us upside down, nor would it have found himself the subject of my puzzled scrutiny. And if I hadn't spotted Saeko filching the *formaggio al peperoncino* at Kanekoya Supermarket, then I wouldn't be here looking at the Egyptian Russet Bat.

I sighed. My imagination ran up and down the chain of interconnected events, but there was no end to it. The thread of connections stretched far off into the past and the future. The bat flapped its cape disconsolately over its chest and shifted its weight from foot to foot. I had the feeling that it would take more than a decade to explain everything about that creature hanging there silently in the cage. There was an integrity, a pathetic kind of dignity, in its having come from such a faraway place to dangle upside down like that. When it came down to it, the bat had been pulled into the business of Saeko's water just like me. I felt a surge of affection for it.

"Pepe, that's his name. I called him that. Egyptian Russet doesn't exactly roll off the tongue. And I christened his girlfriend back in the shop Pipi."

It was hard to believe Saeko had been crying, she sounded so cheerful.

"I'm thinking of arranging a Pepe and Pipi reunion."

"Enough stealing," I shouted, horrified. "Please. From now on I'll be more serious about pumping your water."

Water Erosion

The Multi-Month Campaign was in its final, crucial stage. There were only ten days left.

The campaign director's voice came out of the speakers sounding cracked and hoarse at the morning meeting, while

Suzuki, our good-natured boss, looked more anxious by the day. We had got off to a flying start, achieving fifty percent of our quota in the first half of the campaign, but the bar chart had moved upward more slowly in the second half, and now it was touch and go whether we would manage to sell the other fifty percent of policies in time. The one-eyed Daruma in front of the chart glared at us. Every day the saleswomen's faces grew more sunburned, turning the color of miso bread.

I had still not sold a single policy. But the graph in my heart was shooting up like a fountain whose control system had gone haywire. Even at the most conservative estimate I reckoned I'd probably helped Saeko spout more than fifty liters of water. The math was as basic as it gets. One round of sex was two liters, and we'd done it twenty-five times, which made 50,000cc. Altogether that would come to more than thirty-three big bottles of Evian. Or more than twenty-seven of those 1.8L bottles of Kikkoman soy sauce. I shut my eyes and pictured myself as the Evian factory boss, standing proudly among rows of blue bottles brimful of water.

Vis-à-vis Suzuki, my immediate boss, and all the sales staff, my behavior was quite inexcusable, but privately I was elated by the runaway growth of my water graph. The bat-stealing incident that took place during my six-day absence made me a more frequent visitor to Saeko's house than before. I crossed the red humpbacked bridge almost every day. In this part of the country, the rainless rainy season was followed by an equally rain-free July with cloudy, muggy weather. Water restrictions were introduced in some areas, but Saeko continued to be copiously productive.

Pepe, the Egyptian Russet Bat, hung upside down and looked at us unblinkingly from its cage out on the laundry deck. I would sometimes catch its eye while busy making Saeko squirt.

Saeko had dug a thick plastic raincoat out of the store-room. Dark blue and with a hood, it was the right size for a tall man. Perhaps, I thought, it had belonged to her father, who had walked out of the house and disappeared. We laid it on the floor and made love on top of it. It felt nice and cool against my back, and collected the water better than the tablecloth-like thing we'd been using before. I scrupulously collected all the warm water in the hood. When I picked it up carefully with both hands and peered in, I saw two eyes reflected in it. The water's eyes. I then tipped it off the laundry deck, pouring it out slowly to avoid giving Saeko's granny a surprise. The hood was always about the weight of an adult's head. The trumpet vine seemed happy to feel the water snaking and rustling through its tendrils and sucked it in with greedy slurps, while the red of the flowers and the green of the leaves deepened. Pepe's eyes would glint like shards of obsidian at the sound, and he would give a discreet shake to the black cape folded over his chest.

Saeko's water showed no sign of diminishing.

Was she hiding a load of Evian or Southern Alps Springwater in the shed and guzzling bottles of the stuff the minute I went home? Maybe instead of blood, she had warm water flowing through her veins like the many branches of a river! Or did she accumulate water by soaking up the moisture in the atmosphere through her pores? Was there any chance that she was linked to the Kikoshi River by an invisible tributary? I ran through the various possible answers as I looked down at the Kikoshi on my way home at night. But in the end I pulled the plug on these speculations, since they all seemed credible and incredible in equal measure.

The cause was always overwhelmed by its own effect. Just like with a major earthquake. When the building they're in is

being shaken around by a big tremor, nobody gives a damn about where the epicenter of the quake is. Same thing here. With Saeko's water, I suppose the reason for its coming out always ended up being swept away by the fact of its coming out. How fantastic to be the author of an effect so powerful that it could sweep things like thought and inquiry to one side! It was just incredible.

Like a Möbius strip, all there was was the effect. No start and no end. No back or front or side. Saeko's water was a warmish, pale blue Möbius strip. And I was bang in the middle of it. Choking on the smell of it. My swollen balls, for God's sake, were as floppy as tofu. My hair was starting to turn gray, and my skin was as thin and flimsy as a sheet of paper. I was being eaten away by the water. But being eaten away by warm water felt good. Wonderfully safe and secure. And the bat watched from the laundry deck, upended by the gravity of things. Aah, the sheer pleasure of being watched by the round eyes of a bat that had come all the way from a country far, far away . . .

Saeko went and got Pipi, the other half of the pair, actually paying for her purchase on this occasion. So she'd ended up getting the two of them for half price. Had the woman no sense of shame? It made me mad. The whole arrangement of what she was or wasn't ashamed of was seriously out of whack. But everything like that was swept away by the water that carried all before it.

Pepe and Pipi. There was now a row of four upside-down, blackish-brown Egyptian Russet Bat eyes on the laundry deck watching Saeko squirt. We were getting on fantastically. I loved my splashy Saeko deeply.

Break

I haven't told anybody else this, but at the height of my involve-
ment with her, I often had the urge to tell Saeko's story to the
newspapers and the TV. In fact, I was rather amazed that the
media hadn't come around to interview her already, and I even
toyed with the idea of contacting them by phone myself. I wasn't
planning to profit from this personally at all. The feeling is com-
mon enough, surely: when you know something no one else
does and you're not allowed to talk about it, it just makes you all
the keener to spill the beans.

If old hat like UFOs and spoon-bending can get on the TV,
there's no excuse for not giving airtime to the story of a woman
who can squirt out two liters of water at one go. If a morning
slot wasn't possible, then some late-night show would be fine.
Frowning disapprovingly at the presenter's sardonic smile and
probably indelicate line of questioning, I would mobilize my
entire vocabulary, inadequate though it was, to give a passionate
and detailed explanation of the wonders of Saeko's water.

But as it happens, I've never told anyone about Saeko until
now, and I've never been on TV, either. I took my pleasure in her
privately, never sharing the marvel of it all with other people.

Why was that? I wonder.

I suppose it was because neither Saeko nor her peculiarity
could be turned into token conditions. Smooth-talking com-
mentators might try to do so, calmly discussing two liters of
bodily fluid as though universal conclusions could be drawn
from them. But the reality was too real for that, provoking noth-
ing but a baffled sense of pity in the viewer, or maybe a kind of
offbeat thrill. But that's the way true stories tend to be. They
defy universalization. The more you tell them, the more likely

they'll degenerate into an off-color joke or a fanciful anecdote. Enjoyable though her water was, I was instinctively aware of this and would always pull back from the brink when I was at risk of confiding in someone. As a consequence, I played in the water all by myself. And I liked it that way.

Why, then, am I telling you all about it now? Thoughtlessness, that's why. I started talking out of sheer thoughtlessness. Anyway, it's too late to go back now.

I appreciate your listening to me. Let me press on with my tale.

A Dream

The second eye of the victory Daruma was filled in two days before the Multi-Month Campaign was due to end. The saleswomen had put in a final frenzied spurt and filled our assigned quota for policy sales. In the evening, someone went out and bought some booze and we had a party in the office to celebrate our success. A fragrant pressed-flower telegram came from the campaign director, which our boss read out in ringing tones: "I am truly delighted at the triumph this office achieved in the Multi-Month Campaign. My gratitude to all of you for your hard work." Suzuki himself had tears in his eyes as he shook hands with each of us before inking in the Daruma's second eye. We gave three cheers, followed by a toast with cold sake. Suzuki's face and the sunburned faces of the saleswomen glowed with satisfaction. The boss clasped my hand in his beefy paw. "Hey, I bet you learned a lot from this. Better luck next time, okay?" he said.

Everything was going well. As I walked along the riverbank in a mellow mood, I heard the sound of frequent splashes as baby

carp leaped out of the water into the moonlit air. Everything
was going swimmingly. From one bridge to the next as far as
the last humpbacked one the water and the moonlight flowed,
while muffled grunting came from the Hanamura Dojo and a
stream of newborn babies popped into the world at the Kiku-
jima Clinic.

At Saeko's place, the Egyptian Russet Bats, Pepe and Pipi,
were waiting for me snuggled up to one another like the black
twins. The dark-blue raincoat had been hung out to dry in the
daytime and Saeko had spread it over the futon. Naked, she
lay on her back with her head in the hood of the coat and her
arms, which she'd slipped into its baggy sleeves, crossed over her
chest. "Look at me. I'm a bat!" she joked. Naked myself, I dived
onto the coat and we turned into a breeding pair of bogus bats
as we started mating. Pepe and Pipi looked on. As she moaned
and grunted, Saeko told me that after I'd left last night she'd had
a weird dream which had made her squirt again.

"It was a moonlit night. I'd gone to throw the fortune slips
Granny had written into the river, when I lost my footing and
ended up underwater. Then I started to float along on my back,
but I was still—this is a bit weird—holding the fortune slips.
I was somewhere upstream of the First Bridge. I don't remem-
ber my back ever touching the bottom, so the water must have
somehow become a bit deeper."

In her dream, Saeko had been carried slowly down to the
bridge, gazing up at the moon, with her head pointing down-
stream.

"It wasn't just the moon. I also had Pepe and Pipi wheel-
ing around in the night sky. Giving out these amazing waves of
ultrasound, pi-pi-pe-pe. I could actually hear them, but naturally
I'd no idea what they were saying. It felt nice, though—like a soft

breeze licking my earlobes. Anyway, I just drifted along like this on my back."

The water had been rather cold at first, but as she got closer to the bridge, it was so pleasant that she began to feel drowsy and there was a faint smell of what she described as lavender potpourri. Now and then she felt the carp sliding against her bottom, but they never got up to any serious mischief.

"When it comes to making love to a woman, water's an expert. Because it never overdoes it in any one place. I guess it's that it kind of softly slides in everywhere. I was spouting by the time I was under the bridge. It's embarrassing, but it just came out on its own."

There was a gentle tinkling of water on the raincoat.

"My water's just a teeny bit warmer than the river. And it floated along with me. As I passed under the bridge, there was the sudden sound of high-pitched voices. Those black twins were down there, pointing at me with their black fingers and jeering. They really overdid it, jeering at me for making water like that. I thought I'd die of embarrassment, but the stuff kept gushing out, so all I could do was wait till I was swept past."

Pepe and Pipi accompanied Saeko like a security detail. The moon illuminated her as she floated downstream.

"A man stood slumped over the balustrade as I glided under the second bridge. Then, sure enough, when I passed the third one, there was a woman standing there craning down toward the river. Each time, I got a bit of a shock and wondered to myself: Was that my father? Was that my mother? But the river just kept pulling me along, and I kept on spouting water."

Neither of these things stopped flowing, but as she approached the fourth bridge there was a subtle change in the river water.

"Compared to the water farther upstream—I'm not sure if

I can say exactly what I mean—it was softer and it tasted nice when you licked it off your lips. It was gentler, smoother, I suppose. I got carried away and started drinking it and it made me feel deliciously lazy all over. That water was wicked. I'd realized this by the time I got to the brackish stuff. I drank gallons of it even though I knew I shouldn't. Then I started tingling all over and it poured out of me in even more obscene amounts."

Saeko paused for breath. A shallow stream was now purling across the raincoat.

"Bit by bit I was getting closer and closer to the sea, and when I got to the humpbacked bridge just out there, the water got a little warmer—exactly the same temperature as mine. This just made me come even more and soon the surface was dimpled with little whirlpools. I was close to passing out . . . It was horrible."

Warm water slopped off the raincoat. Pepe—or was it Pipi?—reacted as it dangled there by unfurling its black wings and exposing its squirrel-like body.

"I spouted so much . . . so much . . . spouted till there was nothing left, then I swallowed so much water that I woke myself up . . . The futon was soaked through. Oh, it was a horrid dream."

An amazing dream, I thought with a sigh. As I lay there in the tepid pool on the raincoat, Saeko's dream became mine. Now I was floating down a warm river. The only difference was I couldn't do any spouting of my own. All I could do was make her spout or be spouted on. Exasperating.

Saeko's tone changed.

"This dream could be a good sign. It's telling me that I can get all the water out of me. That's my feeling, anyway . . . Because when I woke up, you see, I was still holding the fortune slip. Something Granny'd made specially for me and given me last night after you went home."

I asked her what category of fortune it was this time.

"Supreme Good Fortune. My first time ever," said Saeko, sliding her wet body over the tatami and extracting a crumpled little card from the dresser drawer.

Instead of a poem, there was a single rather upbeat adage written with precise brushstrokes. "Visible between the waves is the tower adorned with the painting of the seven treasures. Take advantage of it." Sure enough, off to one side were the words: "Good Fortune." The penmanship was unprofessional but no worse than the handwritten menu boards at pubs. "Your Wish" was "Soon to Be Fulfilled"; "Sickness" was "Complete Recovery Imminent"; "Marriage Offer" was "Yes"; and "Moving House" was "Propitious Time."

"See, the 'Lowest Level of Luck' I got last time has switched to 'Supreme Good Fortune'! My 'Wish' is about to be fulfilled! And my water sickness is going to clear up completely! I just know it. And all thanks to you!"

Saeko was sitting naked on the tatami with her heels tucked neatly beneath her. She was glistening with moisture as though her skin had been wrapped in a thin layer of silver foil. The down on her long white neck was as radiant as the frost on a tree trunk. I quickly sat up and Saeko pressed three fingertips of each hand to the floor and bowed so low that her head was squashed against the matting. I heard a voice coming from the tatami. It sounded like the warm water speaking.

"I am not asking you to say it straightaway. But if my water sickness gets better—no, I mean when *you* make me better—I'm hoping to become a normal woman. I know I've been a thief, a bad person . . . But will you still be there then? Or will you turn me down?"

"I won't say no," I replied stiffly, more as a reflex than anything

else. But even as I said the words, I had a feeling that something had gone badly wrong. In some corner of my brain, I could hear the solid earth and the seawater rubbing up against each other.

Sweet Bean Jelly

It was the first Sunday of August. I crossed the red humpbacked bridge. The Multi-Month Campaign and the ceremony for the company's anniversary were both safely out of the way, but my personal multi-month campaign was not yet over.

Saeko brought me one of the bean jellies that was for sale from downstairs. It had been poured into a plastic mold and was nicely chilled. I ate it sitting side by side with her as we watched the sea darken. Discreetly sweet, it cooled my throat as it slid down. Saeko was sweet to me. Pepe and Pipi contemplated us upside down while we contemplated the sea.

"It's amazing," she whispered. "The right amount of water, I mean. Let's say I make eight molds-worth of sweet bean jelly. You've got to have exactly 200cc of water to the 5 grams of vegetable gelatin and 160 grams of adzuki jam. 190cc, or 210cc, and it's just no good. The jelly will be too hard or too soft."

What was her point?

"Same with the flour you add to the melted gelatin. You need 75cc of water to dissolve 3.5 grams of the flour. 76cc just won't do it. It just won't."

"And so—?"

"—so, it's amazing."

"How so?"

"How so? Water's got no shape of its own and is lying around all over the place. In rivers, in lakes and in the sea. Just any old how. At least, that's how it looks, right?"

"I don't get it."

"But the amount of water in the sea—" Saeko pointed in that direction "—I'm sure it's a specific amount for a specific reason. I'm sure there's a reason why there isn't 1cc more or less of it than there is right now. Exactly like the water in this sweet bean jelly."

"Could be."

"But—"

"But?"

"But the water inside me isn't there in the right amount, and I don't know why."

The wrong amount and no reason. Was that really so bad?

"There's nothing wrong with your having lots of water, provided you don't steal anything. No one could criticize you for that."

"No, you don't get it. I'm unhappy because it's the wrong amount. Like a sweet bean jelly that breaks up because you've added too much water. When people find out, they'll make fun of me, sneer at me."

"Well, I won't. As long as you don't steal anything. I won't just not criticize you, I'll actively support you. Protect you from the creeps who snigger and sneer. You've got loads of water, fine, just spout it all out with me."

I meant what I said. Pepe and Pipi watched us upside down.

"No. I know that if we lived together for years and I kept on producing all this water for no good reason you'd eventually turn against me. Probably start saying things like, 'Keep this up and the house will rot away until the whole darn thing comes crashing down on our heads.' I just know it. And in the end you'd say you prefer the proper amount, and you'd leave me for a woman who's got it. I just know that's what you'd do."

I'd never do a thing like that. Oh yes, you would. No, I

wouldn't. Yes, you would. After this back-and-forth, Saeko came out with: "So, when I'm cured I'm going to marry you. After all, there are signs the volume's on its way down . . ."

We lay down again on the blue raincoat feeling conscious of a slight rift between us. Noisily, unreasonably, Saeko dissolved. I felt soothed and comforted as it washed over me, and I wanted to be with Saeko of the wrong, not the right amount, forever. Wiping me with a towel, she said: "I think there's a bit less now. I haven't pinched anything since you know when. And this is all the spouting I'm doing. Thanks to you."

Banana

I crossed the red humpbacked bridge again.

Saeko was crouching on the laundry deck feeding some chopped-up banana to Pepe and Pipi. "Look. These little guys have got canines and molars. The only flying mammals, and they've got wings attached to their arms and can do all sorts of amazing things!"

When she brought the chopsticks with the banana up near their noses, either Pepe or Pipi would open its mouth so wide that its head seemed to split all the way up to its eyes. Saeko could tell the two of them apart, but I couldn't. She was right about the neat rows of tiny teeth they had on their upper and lower jaws, but even a fleeting glimpse made their faces look evil. That, I thought, is what bats really look like.

But I couldn't help feeling sorry for them, coming all the way from the Middle East to have their teeth subjected to a quite uncalled-for inspection by some Japanese man who, on top of everything else, called them evil-looking. Idly, I considered again

the countless links in the chain of events the bats had passed through, and the not inconsiderable number of events that had happened to me too. Beyond the laundry deck the twilight sea stretched out like an ultramarine rug.

"I heard they make love in autumn," said Saeko. "Afterwards, the sperm's carried for months in the body of the female. She flies around, caring for the male's little offering all the while. Ovulation and fertilization take place in the spring of the following year and it's early summer before a baby—just one—is finally born."

I suppose she wanted to make a parallel with our getting married, I thought to myself. It was a story she must have heard from the owner of the pet shop where she'd stolen Pepe. The fact that she'd paid for Pipi may have halved the original crime, but there were times when I detected a residue of shamelessness in Saeko. But that feeling was washed away by the water, along with everything else. Everything was swept away—and it just felt so incredibly good.

"What do you think the newborn baby does when its parents are flying around?"

"No idea," I said.

We never got into a flap about Saeko getting pregnant. Probably because that possibility was always flushed out. She knew it, which was probably why she was telling me about baby bats. If at some point her water ran out, then she would be able to have a baby. At some point. At the end of a long sequence of events. At some point.

"The baby uses its milk teeth to bite into the fur on its mother's chest and hangs on that way as they fly around together. The guy at the pet shop told me so."

Maybe Pepe and Pipi had flown around the pyramids clinging onto their mothers like that. But they were here now.

Saeko's tone changed abruptly.

"They're cute, but Granny's always banging on about them being unlucky and saying I should set them free. She thinks they'll cancel out my Supreme Good Fortune. She's not exactly Einstein to begin with, so I don't know where she gets this idea from."

"Set them free and they'd probably not make it," I said. "No banana trees around here."

Saeko nodded sympathetically.

"Okay, so you have some blood-sucking ones like the vampire bats in South America, but most of them are nice, gentle creatures that just eat mosquitoes and moths and flies and fruit. The poor things are so misunderstood. In China they're a sign of good luck. That's what the pet shop man told me."

The Egyptian Russet Bats gobbled up the chopped banana without bothering to take off their pointy-edged capes. Being upside down, it was something that it didn't get stuck in their throats. Their tummies were bulging under their capes. Even if, as Saeko's grandmother insisted, they were bringers of bad luck, they looked thoroughly good-natured now—just as the pet shop owner had said.

That day, I again pumped water out of her on the blue raincoat, but I couldn't help thinking there was less of it, just as she'd mentioned earlier. As if to persuade herself of the fact, she kept whispering, "There's less. There's less. Less than that time with the sweet bean jelly."

Saeko was happy. For my part, I felt rattled, as if some money had been unlawfully withdrawn from my postal savings account.

Glass

It was now that a rift opened up between my pleasure molecules and my duty molecules, which had previously been the best of friends.

Come to think of it, I'd been conscious of a paradox here since the day I'd given Saeko a hard time for making a puddle after stealing the bat. "Shouldn't you be pleased if there's less water than before?" she'd snapped at me. "I want to produce less of the stuff, or stop completely, if I can." What she'd really wanted to say was, "You should be happy with me." However, I wasn't at all happy about the drop-off. In a way maybe I was even less happy about the decline in water volume than I was about her shoplifting. It was all at cross-purposes. My duty molecules had made a solemn promise to pump every drop of water out of her and to permanently stop her stealing, but my pleasure molecules yearned to feel her warm water permanently washing over them, too. If I succeeded in the former, then the latter became impossible. Pull off one, kill the other. The logic couldn't be clearer.

I cursed myself for not having tried to do something about it earlier. Why hadn't I been a more miserly reservoir manager and rationed the water supply? Because if I'd done so, Saeko might well have gone on a shoplifting spree. It wasn't an easy one to resolve. Weirdly, the harder I worked, the smaller the reward for that work became, like frantically digging the grave in which you'll end up being buried. What the heck had my multi-month campaign during this hot summer been all about?

The first thing I needed was proof. Without proof, I was never going to find a solution. We're all prone to illusions. At least, we are when we want something very badly. Optimists are driven to tears by their optimistic illusions, pessimists to laughter by their

pessimistic ones. Saeko, I suspect, was in the former camp, and me in the latter. What if the drop-off in her water level was just an illusion? My head had been lolling forward but it jerked upright at this thought. Her continuing to spout water all her mortal life became a strong possibility and the honeymoon of pleasure and duty could well continue indefinitely for me. Provided, of course, that my theory of it being an illusion wasn't itself an illusion . . .

I took the plunge in the middle of August. I suggested to Saeko that we try measuring her water.

"Come off it! There's no way you can do that."

I'd expected this sort of resistance. However, I had a second and a third arrow ready in my quiver. I made my case as persuasively as Demosthenes, the Athenian orator.

"We're not going to treat you like a feeding bottle with measuring markings. Let's just be scientific with what comes out. I mean, if the stuff can emerge without anyone even laying a finger on you, then we can easily catch it in some kind of suitable container and measure it, instead of letting it go to waste."

Saeko shook her delicate neck so vigorously that it almost spun around.

"It's too horrid. We can't do it."

"But just think how happy you'd be if we could prove it's decreasing. You could see with your own eyes that it really is gradually going down. Going down, down . . . and with it the urge to steal things, too. You wouldn't have to hang the raincoat and futon out to dry all the time, either. And it's not just about you. Think how pleased your granny would be."

Moistening her lips with the tip of her delicate tongue, Saeko seemed to be licking the individual words as she listened. One more push would do it.

"And if there's actually more water, not less, then I'll just have to work even harder . . ."

Sophistry carried all before it.

It was early afternoon on a Sunday and a number of anvil clouds floated over Sagami Bay. Saeko was in a peculiar pose on the tatami upstairs. From between the clouds the sun shone so brightly onto one side of her body I thought she might get sunburned. If someone with no idea about what we were doing had seen her through the window, he might have thought she was having a catatonic fit. Her back was arched, her head thrown back, and her hands were supporting her on the tatami.

Clutching a beaker, I was groveling on the floor with my head in the V of her pale legs. I looked like one of the faithful making an offering before an unusually low altar. I was talking to the innermost part of the V in a deliberately muted voice . . . "Shoplifting's a lousy crime," I was telling her, putting the heat on like a detective on the crime squad who'd fought his way up from the streets: "—but you, you're not just a common shoplifter. You're the worst kind. It's sexual shoplifting that's your game. You should be ashamed."

I kept talking, rough words on my lips but entreaty in my heart. My hopes may have been the opposite of Saeko's, but I was no less desperate. The crux of the V listened like an impassive ear to my hostile comments. (The thing did in fact look like a well-formed ear.) I have to concede that it held out well at the start. This provoked the cop in me to get even more aggressive. "Hey, c'mon, knuckle down. If I say spout, I mean spout. So I can see it."

The bit that looked like the shell of the ear turned a pale reddish color and began to twitch.

Two or three needle-fine spurts of clear water struck my forehead. Then the needles merged and formed a short arc. As my

nagging intensified, the parabola's silvery line grew longer and rose up higher. The line of water glittered and sparkled in the sunlight from the sea. It was as pretty as any ornamental water feature. I'd not seen the movie *White Threads of the Waterfall*, but I imagine this was prettier than that. There was nothing sordid about it. The water was as clear and shining as a thought on an autumn seashore.

For a while I couldn't tear my eyes away until I suddenly remembered why I was there in the first place and put the glass at the far end of the transparent stream. It filled halfway in no time. "You hear me? No more shoplifting!" The more I harangued her, the more water came out. And the flow changed according to the harshness of my lecture. Sometimes it shot out like a bullet in protest; sometimes it came in a feeble trickle by way of making an excuse; sometimes it folded up completely and just dripped onto the floor.

The water filled the first glass to overflowing, filled a second, and only stopped after filling up a third. I placed the three glasses on the low dining table and had a good look at them.

The fluid was as pale as the blossom of Baby's Breath. In fact, it was almost the same color as the thin skin of the glass. When the beaker was full, the borderline between the water and the rim disappeared and you were left not with a specific quantity of liquid in a half-ovoid container, but something that appeared to be floating lightly, independent and unenclosed, at the end of a long, transparent stem. The water was simply floating there above the table without the need for any sort of container. I forgot all about measuring it and just sat and stared.

In the end, Saeko was despondent and I relieved that a decent amount had come out.

When I stuck my finger into it, the water was still warm. I drank a little and my tongue wistfully recognized the sweetness

of the sweating *formaggio al peperoncino* with its subtle scent of fresh sheep's milk, a memory from the day I had first met Saeko. Neither salt nor fresh water, it was, like brackish water, something in between.

I went back and forth in memory across the red bridge, counting all the kilograms of water I must have induced. As I wallowed in these bittersweet thoughts, the times I'd spent enjoying it in the past and the times I hoped to enjoy it in the future filled me with a mingled sense of anxiety and ardor.

"Three glasses' worth. We'll use this as our standard unit from now on."

Holding one of them in front of me, I spoke solemnly like a scientist with heavy water for a nuclear reactor. Of course, the volume of water in the glasses was significantly less than when we had intercourse, but the amount seemed to be in the right proportion vis-à-vis her occasional emissions and an accurate reflection of the conditions under which it was collected. At least, that's what I decided.

Saeko cocked her head quizzically.

"I thought it had decreased, but maybe it hasn't after all."

"Next time we'll know for sure. If it's the same, up or down."

I was miserable. I felt as if it had gone down a little already.

The next thing I knew, rain had started falling in great fat drops outside. Thunder rumbled somewhere far away.

Break

Whenever I caught sight of Pepe or Pipi back then, I'd be reminded of the story about the canary and the bat. You've probably read it. It's one of Aesop's fables.

The bat asks the canary, who likes to sing in his cage at night,

why he doesn't sing in the day. The canary explains it's because singing in the day had resulted in his being captured, so he'd become more cautious and only sang by night. It's pointless being cautious now, says the bat, you should have been more careful before you got caught. Predictably, the fable ends with the warning that "regretting a misfortune after it has happened is a waste of time."

As I crouched between Saeko's legs to measure her output, I got the feeling that Pepe and Pipi—who had been captured in the Middle East—were preaching the same one-dimensional and banal moral lesson at me, and it bugged me. I could say the same to you, I thought; after all, you're the ones that got caught! But Pepe and Pipi gave as good as they got in ultrasound with shrill, shrieking laughter:

"Look who's talking! Never heard the proverb about spilled water, have you?"

Strike one to you, I thought. And we all laughed a wry ultrasonic laugh together.

But let me get on with my own fable.

Morning Glory

With three glasses established as the standard unit, I dutifully took my measurements at regular intervals. Groveling, as if in some act of worship, I collected the water as it arced out. And I actually pressed my palms together and prayed—but there was no increase in volume. Indeed, it gradually started decreasing. What had been three glasses' worth was down to two-and-a-half by late August. I picked Saeko up and turned her around, inspecting her body like someone looking for a puncture in the inner tube of a car tire. But there was nothing wrong; the volume of water was simply going down.

I started to lose weight. I got out of breath. "You look like you're still fighting the Multi-Month Campaign," said Suzuki, my boss, his irony bang on target, while the saleswomen, their raspy voices teasing, said: "You live all alone and you're not eating properly. Why doesn't one of us come over to cook for you?" The daily singing of the company song wore me out. By the end of August, the water was down to only two glasses.

It was the first Sunday in September.

When I crossed the red humpbacked bridge at nightfall, my feet felt as heavy as if I were dragging lead weights after me. Leaning on the balustrade to catch my breath, I saw two things that looked like ragged black handkerchiefs flapping their wings low in the dark blue sky. Was I imagining things? Two Rorschach test inkblots were diving down to the river's surface, then flying up again. It was Pepe and Pipi. They were free and flying in the Japanese sky for the first time in their lives. They had lived in captivity for such a long time that perhaps the chest muscles that controlled their wings had weakened, because when they dipped down they looked like they were going to plow right into the water before they bobbed back up, beating the air with their webbed arms.

"I came back from the shops and the cage door was wide open. It must've been Granny. She was always going on at me about how they were bad luck and I should get rid of them," explained Saeko, who was deeply upset.

"Can you see how they're flying around the red bridge and staying close to the house, though? They must still feel a connection. I'm sure they do."

We stuck our heads out of the window above the river and looked at Pepe and Pipi flying around for a while.

"Maybe it's for the best after all," whispered Saeko. "I suppose mating inside the cage can't be easy. Outside, it might happen. Gradually they'll remember how to fly properly, and one of these days they'll mate. Listen. Don't you feel like you can hear them? Every second, apparently, they're sending out 48 kilohertz waves of ultrasound out there in the night sky."

Certainly, that was quite a racket they were making at the bridge. Eventually, they melted away into the darkness underneath it, where they must have hung side by side.

That evening the water was down to just one glass.

In line with my measurements, the pleasure I got from Saeko's warm water had dwindled to a third of what it was before, even when we really made love. I could squeeze her as if I were wringing out a towel, but a third stayed a third. I missed the days when she'd almost drowned me in three times as much warm water! They seemed so long ago. Where had the other two-thirds gone?

There was a splendid, antique-looking toilet in the upstairs bathroom in Saeko's place. For some reason, I suddenly became acutely concerned about the men's urinal there, which I'd not paid any special attention to before. A funnel-shaped piece of blue porcelain decorated with a flower design, it was the so-called Morning Glory model. I began to suspect that there was another man doing his business in the Morning Glory.

After I'd not visited her for a day or two, I'd find the petals on the inside of the bowl shining a vivid, wet-looking blue. Like a dog, I would thrust my snout up close and sniff, but never managed to pick up any clues, because Saeko cleaned the thing as thoroughly as she would a vase.

Sometimes the bolt (she told me it was called a monkey lock) of the wooden door would be unfastened. "Why isn't the monkey lock on the toilet shut properly?" I'd diffidently inquire, but Saeko would make some perfunctory remark like, "Oh? I wonder why." She sounded like she was hiding something from me.

Was there another man coming to the house? Maybe it was Saeko herself, not her grandmother, who had released Pepe and Pipi into the night sky, because this male visitor of hers didn't like bats? Was there a new key unlocking her gate? A bigger and stronger key than mine, perhaps? Was the bastard chuckling happily to himself as he enjoyed two-thirds of the water, leaving the remaining third for me purely out of pity? And knowing Saeko, any sign of her water level diminishing, however it happened, would be a cause for celebration.

A water thief!

Whenever I went over to the house, I wearily scrutinized the blooms on the blue porcelain Morning Glory and examined the monkey lock for fingerprints. In the course of this, the water went down from one glass to only half. Not a drop more would come out, even when I prostrated myself between her legs.

I even hid at the end of the bridge in the middle of the night. I wanted to catch that lousy water thief. But nobody came. Pepe and Pipi flew around wildly enough to make the whole bridge spin and mocked me with their piercing 48-kilohertz laughter.

Heavy Rain

It was a rainy morning in the middle of September, and I was sleeping as deeply as the wreck of a ship that's had the bottom of its hull ripped out when I got a phone call from my mother in the country. She hadn't yet made a complete recovery, but

she was a good deal better and had just been discharged from the hospital. "Hey, that's great," I responded. "You don't sound so good yourself," she said, then waited for my reaction, not hanging up, but not saying anything, either. I pictured the solitary, sick, needy and wrinkled ear pressed up against the receiver at the other end of the line. I too had a single miserable ear pressed up against the receiver. Although I wanted to quit my job at the insurance company, I decided to say nothing about it.

"No, I'm okay."

I spoke brusquely.

"Are you sure? You sound dreadful. Sure there's not something wrong?" my mother asked. For a long time neither of us said anything.

Eventually, a sound like the sighing of the wind came down the line. Was that her at the other end? Maybe she wasn't really better after all. A surge of compassion ran through me and my ear opened up as wide as it could. Mixed in with the wind was a soft swishing noise like a showerhead. Slowly becoming clearer, the noise made its way through the holes in the receiver and washed into my ear: it was the sound of Saeko's water that I missed so much! Not wanting my mother to hear it, I quickly put the phone down. I pressed my head against the pillow, but I could still hear it. The stuff inside the pillow made the same squishy sound. I lay still and listened.

That was the day her water dried up.

I prodded her, sucked at her, shook her and turned her upside down but it made no difference: not a drop came out. I even spanked her on the bottom. I was like a drinker unwilling to accept there's nothing left in the bottle.

"Stop it," said Saeko finally. "There's none left. Don't try and get what just isn't there."

The voice of an empty vessel had spoken!

Hearing her, I felt as forlorn as a lone wooden stake sticking up from the floor of a dried-up lake. Though the stake's every inch was marked by the memory of water, the water itself had inexorably withdrawn.

"What about saying, 'Hey, that's great,' like you really meant it? And I'll say, 'Thanks,' and I'll really mean it too."

Saeko was on cloud nine. I said, "Hey, that's great," but it sounded like I was reading aloud.

How ironic. Outside, the rain was pouring down. The Kikoshi was surging along in full spate, making the wooden house shudder, and the sea was dark and swollen. Saeko and I stood by the window overlooking the river. The thundering, muddy-yellow water was almost touching the bridge's girders. The brackish water was gone. What did I care about her weird and wonderful puddles? The carp and their babies, the black twins I had seen at some point, the green parasol, the striped parrotfish, my memories of the *formaggio al peperoncino* and the fireworks—all were swept away by the muddy water. All the many individual links in the chain of events were uncoupled, smashed to pieces, and carried off like so much garbage.

"Let's hope Pepe and Pipi are all right," said Saeko absently.

Cold Fog

All the same, I found it hard to accept that so much warm water could have disappeared down to the last drop. I began to obsess again about water when the long days of September rain finally ended and the river and the sea regained their rich blue and the

little puddles dotting the road started to glisten in the sun. The truth is, I didn't like letting go. The memory of water had seeped too deep into my mind.

Where Pepe and Pipi had been hiding I don't know, but they suddenly reappeared on the night of the new moon and resumed their mad flitting around the red humpbacked bridge. I had a feeling that the snapped-off chain of events was getting back together again. I was longing for Saeko's watercourse to revive.

I'd done my best to be vague and noncommittal about the business of our getting married when her water ran out. My inclination was the opposite. I hadn't been asked, but I still hoped to make a glorious comeback as the sacred, one and only water key. With things the way they were, I wasn't going to start insisting on two liters of the stuff. No, I now realized how wasteful my previous use of water had been. I'd let it stream out, made no effort to stop it, wasted a resource which had built up over time. Two hundred milliliters would be fine now. I would value it all the more because there was less of it and savor every drop like a traveler in the Taklamakan Desert. The fact is, I was as full of remorse as a fool who's consumed his whole water supply in the early stages of his journey through the desert.

I hadn't touched Saeko since the day it rained so hard. A certain amount of water must have built up inside her by now, I assumed. The office tear-off calendar had "Cold Fog" on it on the day I crossed the red bridge and tried making a proposal to Saeko.

"It's been ages. Would be nice to have a bit of a lie-down on the blue raincoat . . ."

The raincoat, with all its associations, might do the trick. It was just a hunch I had. Saeko stared at me as though I were a pig that had suddenly started talking Hindi. Her voice was hard and dry.

"Oh, for Christ's sake. It's cold, and my water's over and done with!"

"Hmm, I'm not so sure. It might have built up again."

"It's finished, I tell you."

"Sometimes something or other can make water gush up again from a well everyone thought was dry. A minor earthquake far away and a stream over here comes back to life . . ."

"It's finished."

"Okay, if it's finished, it's finished, but there's no harm in having a go. It's unlikely, but if there is any left, we'll need to come up with a plan . . ."

Saeko reluctantly got out the blue raincoat and spread it on the tatami. "What's the darn point?" she muttered. "There's none left."

It was true. There wasn't a single drop. All that remained was the smell of that summer's warm water which had seeped into the raincoat. Aroused by the smell, I pinned Saeko to the floor and bore down on her like a steamroller rumbling over her to squeeze any liquid out. Saeko wept and flailed about. An off-putting noise came from under the tatami, as though someone were banging something on the downstairs ceiling. Pepe and Pipi flew up to the window overlooking the sea, suspended themselves side by side from the eaves and peered anxiously into the room.

We sat up on the coat. It was like sitting on the floor of a waterless swimming pool. *Thump-thump-thump-thump*. The banging on the floorboards under the tatami went on.

"Granny's bashing the downstairs ceiling with a broom handle because she's angry. She's telling you to get the hell out. She knows you're trying to force me to spout even though I've got nothing left inside me."

My head drooped.

After a while, Saeko said: "You can't seem to love an empty, waterless water bottle. Let's face it—all you ever loved was the water, which darn near wrecked the container!"

I thought about the custard cream in waffles, the cream in cream puffs, the bean jam in bean-jam wafers, the meat in meat buns, the roe in herrings, the coconut water in coconuts. Then I had a go at reversing the thought: a waffle with no custard cream, a cream puff lacking cream, a bean-jam wafer devoid of bean jam, a hollow coconut . . . Saeko's point was probably right.

Thump-thump-thump-thump came from under the tatami.

"For me—the container—the water was a source of shame. What you loved was my shame, not *me*—the thing that held that shame. I'm right, aren't I? I know I am."

Saeko was pointing at me like someone pointing a pistol. Her voice echoed as if in a drained swimming pool.

So all along I'd been soaking in two liters of shame each time, I thought. But it had felt so nice and warm, that shame.

"You're—oh heck, what's the word I want? You know, somebody fit and healthy?"

"An able-bodied person?" I suggested quietly.

"Yes. You're able-bodied and normal and you're discriminating against me. Taking pleasure in another person's misery."

"I am?" I didn't know whether to accept or reject the charge.

Thump-thump-thump-thump.

Grandma downstairs was hopping mad.

Gingerly, I asked her something back, something that had been bugging me for a long time.

"But didn't it feel good when you spouted?"

Saeko looked down, thinking hard. Then she looked at me.

"The two things were part and parcel. Shame and pleasure.

Interconnected. But I thought they should be separate. That's what I always thought."

I sighed. Aah. Is there such a thing as pleasure without shame? I'm lying on the beach in October, looking through my narrowed eyes at the cumulus nimbus and the stretch of sea below them, and I doze off. It's so nice, so good—but sure enough there's a feeling of shame like an itch somewhere on my back. When I wake up, the sun is a shaft of light falling like Jacob's Ladder from the clouds onto the sea and me. Bathing me. It feels blissfully, ecstatically good—so good that I feel thoroughly ashamed in fact. Organ music. Choral fantasia. Ooh, that feels good. Ooh, I'm so ashamed. When you get down to it, isn't being ashamed what feeling good is all about? Isn't someone who can feel good without any trace of shame just someone who's lost to shame and has no idea what really feeling good means? Gallons and gallons of warm, shameful water, of love juice—that's the best feeling in the whole world. I wanted to say all this to Saeko, but I couldn't find the words.

The Egyptian Russet Bats were looking at me upside down. From Pepe and Pipi's point of view, they were being looked at upside down by me. Maybe this upside-down scene was the end—or could it be the beginning?—of the chain of events that linked Saeko and me and the bats.

Thump-thump-thump-thump.

Saeko's grandmother was banging the ceiling madly.

"So I decided to separate them. Make a nice, tidy split between the pleasure of lovemaking and the shame. Everybody else all over the world gets to enjoy making love without such horrible amounts of that damned water—without any at all! And now I can too."

Saeko's eyes bored into mine. My water's finished. Well,

what're you going to do about it, they asked me. My mouth opened like a crack in a patch of parched earth.

"The thing is, I'm in love with the Saeko who spouts loads of water."

My final word.

But before I'd even finished speaking, Saeko's answer hit me like a sharp blow from a dry piece of wood.

"It's good-bye then."

Thump-thump-thump-thump.

The old lady was going berserk under the tatami.

I agreed to part on one condition.

I asked her to do something taboo, something outrageous. This was my last chance, I said, so if she did what I asked of her, I'd leave her and wouldn't make any further trouble.

When Saeko heard my proposal, her jaw dropped and she stared at me as if a couple of golden snails had just crawled out of my eye sockets.

(I'll condense the long discussion that followed. It actually took me three hours to get her reluctant consent.)

As you've probably guessed, Saeko's original answer was an emphatic, one-hundred-percent no. It only turned into an extremely grudging okay because I threw my pride out the window and harped on about how I'd put myself, body and soul, into the pumping of her water. It was barefaced extortion of what you might call the "Water Key Consolation Prize." It was an unmanly, dishonorable stratagem, but I was obsessed. We fixed a date, time and place for a rendezvous, then I went on my way. Saeko's grandmother kept on jabbing at the ceiling with her broom right up until I left.

Cheese

It's a Sunday during the Indian summer.

A man dressed as though he's just been to a memorial service stands at the entrance of Kanekoya Supermarket. It's me in a gray suit, white shirt and a dark brown tie with black polka dots. My cheeks are pinched and haggard and I'm feeling lightheaded. There's every chance she won't turn up. Why should she? I wait impatiently. With every minute of waiting, my cheeks sink in another millimeter.

Nine minutes late, a pigeon-toed woman appears. She's wearing a light blue scarf and a dark blue coat. It's Saeko. Her gold fish-shaped earrings are swaying. A cruel joke? Or is she trying to revive memories of the summer? I don't know, but I feel a surge of emotion at their golden gleam. She takes off her coat and hands it to me. She's wearing a foxy little A-line dress and looks as though she's just come from a smart party. It's a blue mini-dress, well above the knee.

The shop isn't very crowded. Walking side by side, we set off for the cheese counter. On the way, I catch sight of two of the saleswomen from my office across the shelves. They're standing next to each other in the grocery section. In the canned goods section, I see a couple of heads like black cannonballs. One of the cannonballs has a silver earring in its ear. It's the black twins from the First Bridge. Sumire Kawashima, plainclothes store detective, is standing behind the twins, scowling at them.

Luckily for us, there are no other customers at the cheese counter. There's a milky, slightly putrid smell. Only one piece of *formaggio al peperoncino* is left. There are round cheeses and square cheeses, but the *peperoncino* with its orange pattern is easily the best-looking of the lot. It occurs to me that the very

cheese Saeko and I ate together had gone around and come around and made its way back to the display cabinet.

"You really want me to?" whispers Saeko.

"Uh-huh. Let's do it."

I whisper my reply, then leave her, moving along to the bread section on the same aisle where I turn back to look at the cheese.

Saeko takes a deep breath. Her beautiful long flamingo neck straightens, rises. I gaze at her ear. The quivering of the fish-shaped earring sends a flicker of gold down the aisle. Saeko's right hand is trembling. The hand unzips her handbag. The same hand trembles as it slowly stretches toward the cheese on the shelf. I hold my breath. The long fingers close on the cheese. The flat milk-colored slice quivers as it floats through space. The *formaggio al peperoncino* vanishes into her bag with a final coquettish flourish. The memory of what I had seen in the summer flies through the air and neatly superimposes itself on the scene in front of me. The two become one.

Now for the replay. Restart the chain of events from almost the beginning. The thought makes me tingle. It's our last chance. Excitement or exhaustion I don't know, but my knees almost buckle under me.

Saeko isn't moving a muscle. It's as if she's frozen to the spot. Her brown eyes are staring at the "Imported Cheeses" sign. I look down at her feet. The beige floor is shiny. I look up again. Saeko's lips are quivering. She's sputtering like the starter motor of a car on the blink.

My voice is a groan.

"Come on, Saeko! Now! Spout! Spout!"

The trembling stops. Saeko slowly turns and faces me. There's a bashful smile on her face. She shakes her long neck.

Her mouth speaks soundlessly. It won't come. Not even a drop. I'm sorry.

I'm still staring at her feet. At the imaginary puddle. What a wonderful summer it had been!

Saeko comes up to me. She takes her coat. In return, she takes the cheese from her handbag and slips it into the pocket of my suit.

"Good-bye."

The moist softness of her voice lingers. She was gone. As though she'd evaporated.

That's the end of my water story. I've no regrets, but I haven't moved on, either.

What happened afterwards? Well, I did cross the red hump-backed bridge one last time before going back to Tokyo. I looked over the railing and a colorless, odorless compound of two parts hydrogen to one part oxygen was flowing coldly down below. Saeko and her grandmother had moved. Pepe and Pipi had gone as well. The trumpet vine clustered around the house like barbed wire. That was all.

Even now, whenever I see a puddle—it doesn't matter where—it still upsets me.

Pre-water or post-water, I have no regrets, and I haven't moved on, either.

night caravan

there were no streetlights anywhere. No matter how far we went. It was like going deeper and deeper into the belly of a whale. Horribly dark; a disagreeably warm, damp breeze; the air sweet and putrid at the same time. There was something slimy about the pinpricks of light flickering in and out of sight up above the treetops; they looked more like the gleam of fat inside a whale's stomach than like stars. The eight of us were all moving in the same direction through the darkness. At first we just breathed the night air in and out without saying a word.

All eight of us were moving at the same speed. Slowly, very slowly. The intervals that separated us neither widened nor contracted. It was so dark we couldn't begin to imagine that anything bright might lie ahead of us. I felt we'd been transformed into eyeless parasites on a black stomach lining. As we slowly advanced together, our sense of smell was our only guide.

In fact, we were traveling in four *cyclos*. A *cyclo* is a pedal-powered Vietnamese rickshaw that looks like a bicycle with a

passenger seat and a couple of wheels in front. We were six men and two women. Four of us were getting a ride: two men (including me) and two women. The others were the *cyclo* drivers.

We moved in a silent procession—one driver behind each passenger—along a straight, unlit road. I was sitting in the darkness as though magic were keeping me afloat on a black void. My back was straight and my hands were neatly on my knees. I was not relaxed. This form of travel, particularly when late at night, is not relaxing. Doing something casual like crossing your legs just seems wrong. In the *cyclo* at the front was the older of the two women; next came a girl with long hair; third was Nyem, a man with a harelip; and my *cyclo* was last of all. I listened to the driver panting against my back.

The woman at the front turned around and said something. The younger woman in the second *cyclo* cackled, then swiveled in her seat to pass on whatever it was over her driver's head to Nyem. Nyem didn't laugh. He turned and, speaking past his driver, translated it into English for me.

"She said: 'My dead father, he say, lice have no eyes. But my father, he was blind hisself!'"

I remembered the old saying: *A louse has no home of its own.* They're always migrating from one clump of hair to another. Is it something to do with them not having eyes? Doomed to live in perpetual darkness? My crotch started itching and I scratched it through my trouser pocket. The crab lice had been down there for a month now.

The head of some large, luminous thing was coming up the road toward us. It looked like a one-eyed deep-sea fish. It rumbled and roared toward us. Our drivers all steered their *cyclos* onto the right-hand shoulder of the road and waited there. First came a motorbike. Close behind it was what appeared to be a

huge black box that made the ground shake. I guessed the motor-bike was acting as its escort. I only caught a momentary glimpse of its bulk in the darkness. It was a bus. Its headlights and tail-lights were smashed and not working. All the windows along the sides were wide open and the night air blew right through them. They were just metal frames—perhaps there'd never been glass in the windows in the first place. Apart from the driver, I thought the bus was empty until I saw a lone face by a window in the back. A dark face in profile. It looked unimpressed with the journey.

The smell of gasoline and dust faded and the sweet, putrid smell returned. We pushed on in single file.

The woman at the front again shouted something. The second woman sniggered obsequiously and relayed what she'd said to Nyem, who passed it on to me grumpily in English.

"'My father, he say, if lice live on person with dark skin, then they turn black, and if lice live on somebody white, they turn white. But my father, he never actually saw one for hisself,' she said."

It being so dark now, I wondered if the lice were black. I scratched my groin and tried to remember the name of the woman in the front *cyclo*. I'd not seen her for a month before we'd met again at the bar. A broad-faced woman. She had a blue bruise on her left cheek that had not been there before. As big as the palm of my hand. When Nyem emerged from the back of the place, I was eager for a glimpse of his grubby right hand. I could still remember her name at that point, but the minute we left the bar and moved off in single file it vanished from my mind.

Suong. The woman's name was Suong. I supposed it was she who'd given me the lice, the blind things that changed their color to match the skin of their host. With the bruise that covered half her face concealed in shadow and such a crowd of black lice

living in her pubic hair, Suong can't have been afraid of the dark as she headed up our column. She was guiding our nighttime procession like the leader of a caravan.

Had we covered two kilometers yet? The sweaty smell of the driver behind me was strong; a smell like wet mud. He was panting more heavily now. Perhaps he needed a break? Maybe his heart would burst? I was worried. But my anxiety soon faded in the darkness.

We had reached a place where there were no more trees along the road and the dark mass of a bank of earth loomed up on the right. I say "trees" and "a bank of earth," but as I couldn't actually see them clearly, I can't be certain that's what they were. Their blackness seemed glossier than their surroundings, breaking through them, perhaps forcing them out of the way. But "seem" is the operative word. It's hard to convey, but I painted their imagined shapes onto a black canvas the minute I sensed something was there. Now I also had the feeling that there were paddy fields stretching out on my left. I'd been sure that the road was completely straight, but maybe it had been veering off little by little all the time. Or maybe we'd turned off it at some point and were now on a different road. Why else would I have had so strong a sense that there was an embankment and paddy fields, and no more trees? Of course, the whole thing could be an illusion. The shapes my imagination was drawing could be totally out of whack with whatever was hidden in the night. I wanted the croaking of frogs and the sound of running water to confirm the outlines of the embankment and the fields. But no water and no croaking were to be heard. The smell of water was all there was. Specifically, this seemed to be coming from my right, from beyond the lump of darkness I was sure was an embankment. Perhaps on the

other side of it there was a big river flowing slowly, very slowly, through the night.

We pushed ahead in a single column, parallel to the suspected river.

The second woman began to sing softly.

Metoidaienzakkubienshau
Botoidaienzakkubienshau

was about all I could make of it. She was young, but from time to time her voice cracked and turned hoarse and rasping. It always went up at the end of the flat, repetitive phrases, and she put more emphasis on the after beat than the early beat. It sounded like the song a young beggar girl we'd bumped into between Hanoi and Lang Son had sung to us as she nimbly beat out the rhythm on a pair of spoons held in her fingers. With no modulation until the rise in tone at the end of the line, it reminded me of the Buddhist sutras. This was just the right song for traveling on a dark night like this, I thought. As we pressed on, it felt as if we were trying to keep time with it.

Every so often I would imagine how the line of *cyclos* must appear across the paddy fields from a distance. The four *cyclos* gliding at equal intervals through the rank-smelling night. The tableau of our little caravan a rectangle cut out of the darkness with scissors. Suong, the young woman, Nyem and me . . . all sitting upright, immobile, gazing straight ahead. The girl's hair was bunched into a ponytail that was streaming into the face of the driver behind her. The drivers were standing up off their saddles, gasping and panting as they leaned forward onto the pedals. We were like a procession of crows. Looking at the others, I wondered where we could be going on so dark a night.

Metoidaienzakkubienshau
Botoidaienzakkubienshau

How should I know, was Nyem's sullen response when I asked him what the song was. I tried to remember the name of the girl who was singing. I had asked about her name back in the bar before this convoy of ours had set off. She was a new face there. She'd been sitting at the back somewhere. A Carpenters song was playing on a Chinese-made radio-cassette player. Nyem was standing looking cocky nearby. I had looked at his right hand with feigned nonchalance, not wanting him to notice. I didn't fancy getting a punch from the same fist that had probably flattened Suong. No, I didn't want a bruise on my cheek too. Curling his thick, reddish black lips, Nyem said in English, she's yours for fifty dollars. Too much, I said. Okay, he conceded, how 'bout thirty? Then it's a deal, he added. "River. It mean river. Same 'ha' like Hanoi. It's popular name. She come from Do Son. Nice quiet girl."

Ha. Her name was Ha. She looked like a nice enough girl with her small face and downward-slanting eyes. She tugged about a third of her bunched-up hair in front of her face and smiled at me through the tousled braid. Her laughter had nothing shrill about it.

Our convoy was slowing. The drivers were tired. But progress was still smooth.

Ha stopped singing. Instead, I heard the sound of Suong chattering for a while. Ha laughed and relayed what Suong had told her to Nyem. Nyem gave me a rambling explanation in English, sounding rather bored.

"'There one kind lice that have white body that shine. Lot of them, they get together and make one big white glow. They look like same you get on your head and clothes, but they longer bodies. That what my father told me. Even though my father, he was blind. But me, I never seen these lice who glow in dark.' That what Suong said . . ."

He gave a deep sigh, it seemed, after finishing his explanation. I imagined him exhaling black breath into the night like a squid emitting ink. Under the influence of the dark around us, even our lungs must have turned pitch-black, since human skin is a semitransparent membrane. The night was blowing right through us. Anything lit up would have to be lice: head lice, body lice, crab lice, sucking lice or chewing lice . . . A crowd of members of one of these filthy species, or a subspecies of one of these filthy species, would be showing a pale, hazy light. The blood they'd sucked would stand out as red as a tubifex worm in the pale glow. As they traveled along with us, the countless lice living in Ha's long hair and my and Suong's pubic hair must be flickering on and off. Out in front, Suong's bush was luminous. Ha's ponytail glittered like a Christmas tree. Back at the end of the line, my pubic hair was aglow. We took it in turns to semaphore. And so our midnight caravan moved on.

I peered down cautiously at my crotch. I thought I could see a few pinhead-sized dots of light there. I scratched myself vigorously through my trouser pocket. The white lights darted about with a faint sound.

Suong shouted something in a shrill voice. She sounded worried. Ha relayed the shout to Nyem; Nyem relayed it to me. Nyem was nervous too.

"Big bright light coming this way. Maybe police."

The drivers steered their *cyclos* over to the verge. Suong, Ha, Nyem and I dismounted and squatted on a patch of grass. The drivers—they must have been worn out—stretched out on their fronts. We waited tensely for the light to pass by. Once again I could smell water, but it was mingled with the fresh green smell of grass. I stood up to see whatever it was that was coming toward us.

There were four circles of light. Two at the front and two at the back. All on full beam. Moving more slowly than I'd expected. The lights got gradually bigger until my eyes had room for nothing else. Eventually the beams blew my eyeballs out of their sockets; bright splinters flew everywhere. Big trucks. Two of them. The ground shook underfoot. The patch of grass shuddered too.

The trucks each had two crane-like objects on their beds. They stretched from the back of the trucks to above the drivers' cabins, pointing up and forward. I craned my neck to look at the first load. Two missiles, their noses as sharp as the tip of a pencil, with four triangular fins that protruded from the narrow body about a meter behind the warhead, glinted a sharp gray in the headlights of the second truck. What I'd thought was a crane was actually a missile launcher! There was a canvas cover over the bottom end of the missiles where the boosters were, but you could still recognize them because the fins pushed it up. They must have been six or seven meters long all told, and the warheads were sticking up at a thirty-degree angle. They looked as though they were about to shoot up into the night, trailing a blue-white flame. We stared at them open-mouthed, still squatting on the grass.

Sure enough, the second truck was carrying another set of the same weapons. Bet they're those Soviet-made Goa surface-to-air missiles, I thought. I had seen photos and film footage of them, but this was my first time to see the real thing. They were of quite a vintage, but when seen from my position and in the middle of the night, there was something awe-inspiring about the way the warheads tapered to such a proud point, and in the brute strength of the rocket bodies wet with cool night air, which made them look capable of reaching the moon. Inwardly

I was shouting, Go on! Lift off! Fly up! I was so excited. And when I got excited, the crab lice in my crotch started moving around. My groin was unbearably itchy. Gazing in fascination at the four missiles going by, I scratched my crotch with my right hand, and the more I scratched the itchier it got. Then we were back in darkness.

The hiss of water brought me back to myself. Without any change in her squatting posture, Suong had pulled down her pants and was taking a pee. It splashed the darkness. The night hid the bruise on her cheek, but I felt I could see her round, moon-like buttocks glowing in the shadows of the grassy verge. Her bush and its inhabitants were exposed to the night air, brushing against the tips of the grass beneath her. I don't like that nasty bruise of hers, I'd thought at first. No, I'd rather do it with Ha. But now I'd changed my mind and felt I'd be happy to go with Suong.

Suong, Ha, Nyem, myself and the four drivers wiped the mud off our shoes on the grass, brushed things like basil seeds and insects like grasshoppers off our trouser bottoms, formed up our column of *cyclos* once again and proceeded one behind the other along the dark, straight road by the embankment. Every so often I would gulp down a lungful of the smell of water that came drifting past. I was acutely conscious of the river flowing noiselessly by on the far side of the bank. When I closed my eyes, I could see our *cyclos* slowly threading their way along the surface of the dark river in a single line somehow held together by sheer determination.

We went on for about a quarter of an hour. Our drivers must have been exhausted. Surely we were nearly there? Had making Suong the leader been a mistake? Maybe Suong and Nyem were plotting something. Maybe the punishment Nyem had

inflicted on Suong with his fist had driven her down to his level.
I had already paid the round-trip charge for all the *cyclos*. Plus
the fee for Ha. The others would probably help themselves to
most of that. Plus the charge for two rooms. It was bad enough
to have Suong come along for the ride, but Nyem, for Chris-
sake! At the bar, Nyem had brushed Ha's hair aside with his
bony fingers, grabbed hold of her slender neck as though throt-
tling a chicken and dragged her over to me. "She nice girl, this
one. Quiet. No trouble. I know you got money. Upstairs here is
shit, no good. Better you go nice hotel Suong show you. Suong,
she work something out with hotel. I come too, as bodyguard,
okay? I keep lookout. Do translation. We get *cyclos* and we all go
together. Yeah. Little bit far away, but it good hotel."

Nyem had wanted to frighten me. And I couldn't deny I was
a little afraid. But fear wasn't the only reason I said yes. I wanted
to know what a midnight *cyclo* ride with them would be like.
What would happen when Suong, who had passed her lice on
to me, and Ha, whom Suong had just hired, and Nyem, who had
just punched Suong, and I, with the children and grandchildren
of Suong's original lice feasting on my blood, all sped through
the darkness strung out in a line like so many body lice? That
was what I was thinking when I agreed to Nyem's suggestion. So
we rode through Hanoi and out into the dark suburbs.

The single line of *cyclos* kept rolling on by the embankment.
I could still feel the presence of that broad artery of water flow-
ing smoothly nearby. I began to think that we would never reach
the hotel, that morning would never come. We would ride on
and on, gliding through the darkness forever.

"Stop! Stop!"

Suong shouted first. Ha then joined in, and when Nyem
heard her—perhaps he'd just got into the habit of sending

everything back down the line—he turned and grumpily told us to stop too. The three passengers in front all dismounted and walked along the ribbon of grass below the embankment, and I did the same. It was so dark that I had to walk feeling out the ground with my toes at every step as though advancing through a minefield. Ahead of me I could see something that looked like a small reddish light. Just one, and very faint. The sight was astonishing. It wasn't seeing it so late at night so much as the position of the thing that surprised me. The reddish glow of the lamp was flickering only about thirty centimeters above the ground. I wasn't used to seeing lights so low down.

It looked more like a Chinese lantern plant than an ordinary lamp; a round little lantern emitting a gentle glow, a blurred halo of pale red light that seemed threatened by the surrounding night, projecting barely fifty centimeters on either side. Beyond this radius was a vast darkness that shone like polished jet. It might have been the center of the universe. At least, that's how it looked to me. Slowly we made our way toward it.

The small, wizened face of an old woman appeared in the halo of light. She was wearing a black headscarf. Her grinning face floated in precarious isolation not far above the grass. I thought it might fall and bounce along the ground. She was sitting with her back to the embankment. In front of her was a small low table like something from a doll's house, while the Chinese lantern was a paraffin lamp about the size of a tumbler.

On the table stood a tea set, a Chinese-made thermos, a bamboo water pipe, eight pieces of fruit the shape and color of potatoes, about ten loose cigarettes, three cucumbers and a plate with a heap of sunflower seeds on it. Taken together they were like props for a magic trick. I imagined the old woman performing feats of magic with her thermos, pipe and cucumbers late at

night on this straight road along which almost no one traveled. Perhaps even the missiles we'd just seen were her handiwork.

Suong, Ha, Nyem and I squatted around the table together with the four drivers and drank tea from small cups. It was horribly bitter. The old lady grinned the whole time. She'd probably been chortling away in the lamplight like this for a good long while before we turned up, knowing we were bound to come, and finding it so funny she just had to laugh. Nyem handed each of the drivers a couple of the loose cigarettes. Without lighting them, they slipped them into their chest pockets and took turns puffing on the pipe that looked like a *shakuhachi* flute. It made a gurgling noise. I opened my mouth wide for the bamboo tube. *Gurgle-gurgle-gurgle*. I sucked in the smoke: it was like the fetid breath of an animal. As the smoke filled my lungs, it crawled up my spinal cord, passed through my medulla oblongata and ran about the crevices of my brain. My whole body spasmed. For a brief moment, alarm caused the crab lice in my crotch to relax their grip on the roots of my hair and several of them tumbled out of the thicket.

Suong bought all three of the cucumbers and the eight potato-like fruit. Nyem looked very pleased with himself as he took the money from me and handed it over to the old woman. She opened her mouth and chuckled again, revealing the hollow inside. We turned and started walking back along the grass verge to the *cyclos*. I looked back and saw the old lady's face once again floating in the halo of light from the Chinese lantern. Around it there was nothing but darkness the color of wet leather. Her expression was irritable now. In the darkness behind her face, you could sense the flow of a river almost as vast as the sea. We moved on again in single file.

The *cyclos* were speeding along as if they had been refueled

when, about five minutes later, the straight road by the embankment suddenly became an uphill slope. The drivers did their best, groaning—*ush! ush! ush!*—as they stood up off their saddles and leaned forward to put their whole weight on the pedals. Had the four of us dismounted, they would have got to the top with ease, but Suong, our commander at the front, was scolding her driver in a shrill voice, while neither Ha nor Nyem showed any sign of getting off. For my part, I was still a bit shaky from smoking the water pipe and didn't feel like walking. But I still kept worrying: Would the pedals turn? Would the chain break? Would the drivers' legs, which looked like strips of dried beef, snap and the *cyclos*—with everybody in them—go crashing back down the hill?

Sure enough, all four vehicles ground to a complete stop just a little below the crest and for one or two seconds there was a stalemate when we neither moved forward nor slid back. We were frozen like a movie still. If we couldn't make the next little bit, we'd roll all the way back to where the old woman was, who had probably foreseen that happening and was waiting, laughing to herself. Even if we started out from there on another attempt, we'd only roll back again just before the top and end up where we started. Who knows, perhaps we'd spend the whole night doing this over and over again . . .

Then, with the driver giving a furious yell—*Woargh!*—Suong's *cyclo* made it to the summit. Ha's driver did the same. The other drivers started shouting *Woargh! Woargh!* all together. Nyem's *cyclo* and mine forced their way up. After all four had made it to the top, Suong began clapping, Ha followed suit, and even Nyem clapped slowly, reluctantly, while I clapped for all I was worth.

The drivers stopped there and took a breather, resting their heads on the handlebars. The crest of the hill was level with the top of the embankment. A cool breeze brushed against my

cheek. I breathed in the smell of water. From the seat of his *cyclo*, Nyem started talking to me, pointing with his right hand into the darkness.

"You see bridge over there, okay? Big iron bridge. Many Russian engineer came here to build it. All gone home now. But they build one huge great bridge."

I couldn't see it. I tried blinking, but I still couldn't see it.

"It too big. They get so many people help making it. I never been 'cross it. This one long bridge."

I tried to draw a line that was blacker than the night on my canvas of darkness. I drew the horizontal span of the bridge, then sketched in the vertical lines of several thick piers. I drew a railing along the edge and tried stringing a few steel cables across its length. And a clumsy, black steel structure linking darkness to darkness became visible at last. I looked at what was underneath it. The area below seemed to have been dug out to a far greater depth than I'd imagined. It was like a gigantic drainage ditch, broad and deep. In it flowed something that looked like black celluloid: water gently unwinding like film imprinted with memories.

Nyem explained that the hotel we were going to had originally been a dormitory for the Russian engineers. Now guys who'd got rich through smuggling or graft went there because it had a sauna and a billiard table the Russians had left behind, as well as a video room and a massage parlor. "I don' like it. It's disgrace!" Nyem seemed to be talking to himself. Then he suddenly dropped his voice and began to talk about Ha. "She try go to Japan. With twenty people and her baby. On fishing boat. But they drift away from East China Sea to South China Sea and end up in Hong Kong. They send her back as economic migran'. She sure no politico refugee! Crazy! When she come back, she got no more baby. Some people, they say she eat it while they drifting on that boat . . . the baby . . ."

Bullshit! She'd never eat her own baby. Even if someone else had. He was probably trying to scare me again. Threaten me so he could get his hands on my money and stop me doing anything with Ha. I pretended I wasn't interested and looked down at the river. It was as black as coal tar. I felt I was inside a sperm whale. The water that flowed by so silently could be its digestive juices. It occurred to me that the water far, far downstream from here might be the sea on which Ha had drifted, holding her baby. Looking at the black, thick, heavy water I felt that even making a run for it—let alone making a successful escape—was never realistic. The crab lice squirmed and I felt a tingling sensation. It itched. I couldn't help laughing. A swarm of eyeless insects on the hair inside my trousers—and me like a blind man in the belly of a whale. The contrast in size made me laugh.

One behind the other, we proceeded down the hill and followed the road around to the left, turning away from the river.

Suong shouted something which was passed back to Nyem.

"Nearly there. We nearly at hotel."

We came across a streetlight for the first time in ages, not far from a level crossing over a railway siding. It was such a relief to see the flimsy wooden pole, tilting over so far it seemed about to topple down. A single little lightbulb shone there with all the majesty of the sun. Suddenly we all looked as shabby as a parade of old umbrellas. Beyond the pole was a tall concrete chimney and a slate-roofed building that looked like a factory.

We rode along a road that smelled of dust. The four *cyclos* came to a stop in front of a building surrounded by a high concrete wall. There was a green iron gate that was shut. A side door just big enough for a single person to squeeze through stood open. Nyem dismounted from his *cyclo* and walked over to me.

"At last we here. You wait here one moment, okay? Suong, she going to negotiate."

Then he asked me for yet more money. A negotiation fee, he called it. He suddenly made a show of frowning as if everything was difficult because "we no have reservation, see." Nyem crammed the banknotes into his trouser pocket and disappeared into the courtyard with Suong, talking to her in a low voice. Ha followed them inside.

I peered into the courtyard through the side door. The walls of the three-story U-shaped building had probably started out white but had turned a grimy shade of gray. Inside the U was a lawn; outside it a tennis court and a basketball court. Both of them had cracks that looked like ground fissures. There was no one to be seen. Near the tennis and basketball courts stood a clump of pine trees. At quite some distance from them towered a jackfruit tree at least twenty meters tall, its ovoid yellow fruit hanging directly from the trunk rather than the branches. Each fruit was an armful. From where I was I couldn't see it, but I knew the skin of the fruit was covered with dozens of nipple-like protuberances. Blots of yellow in the dark emptiness, they looked like babies the tree had given birth to. They looked ready to drop.

Near the jackfruit tree was a pond. The tree arched out over the water, and if its "babies" were to drop off suddenly in the middle of the night they would sink to the bottom in seconds, with no one any the wiser. The pond's surface was like a black magnetic field trying its best to suck the fruit down. Around it were flowers that even in the dark I could see were blue. I caught sight of Ha with her long hair. What was she doing over there? She was looking up into the sky and, why I don't know, waving her thin arms up and down and from side to side. She seemed to be trying to catch something in her hands. As her hair flapped

about, I thought it might get caught in the branches of the jack-fruit tree. Every so often she seemed to be pressing her palms together in a gesture of prayer. I had no real idea what she was doing as the branches of the jackfruit tree hid her frail body every time she moved. But the way she was behaving alarmed me.

Distracted by this sight, I hadn't noticed an odd building up against the wall just to the right of the front gate. It looked quite different from the long narrow identikit main building, being cylindrical and, judging by the windows, one story higher. It reminded me of a pillbox or some sort of military command post. A pallid, yellowish light streamed out from the third- and fourth-floor windows. Something about it made me uneasy. Nyem was standing at the foot of the tower. He was whispering with a woman in white short trousers. Suong was nowhere to be seen.

I waited. I wasn't brave enough to go back by *cyclo* alone. But I'd been kept waiting long enough now, hadn't I? Nyem—and no one else—came over to me. He was in a foul mood. Clicking his tongue in disgust, he started whining:

"We too late. She say sauna and massage both closed. We unlucky. Suong she idiot, get time wrong. She real idiot . . ." After moaning about the collapse of his personal plans for fun, his voice became tired and bored: "So, you want fuck Ha, yeah?"

"Yes," I replied, mainly because I didn't want to end up alone with him.

Nyem led me over to the cylindrical building. I caught a whiff of the muggy, slightly enervating smell of hot water and the smell of something burning. So the sauna was here. By its entrance stood an office desk on which a round, grotesquely oversized clock lay flat on its back like a birthday cake. It was an electric wall clock with a red casing. The black hands pointed to 1:15. The woman in white shorts was humming as she tidied

up a pile of papers on which I suppose she kept a record of the times that the customers and their girls went in and out. Nyem scowled at her and gave a snort. The woman, whose bony backside was facing us, never bothered to turn around.

Soon we were going up the stairs in the central section of the U-shaped block. I held my breath against the stink of urine and mold. Someone must have taken a piss on the landing wall. My crab lice started squirming again. I scratched at them through my pocket as I padded along the second-floor corridor. The floor was green linoleum, like a hospital. There were a lot of rooms. Some with their doors left open. The smoke of insect repellent drifted out. Nyem padded ahead of me. He too was scratching his crotch through his pocket.

Without bothering to knock, he pushed open the door of the room at the far end of the corridor. There were a couple of iron-frame beds. A single naked lightbulb dangling from the ceiling. A fan so small it looked like a toy on the desk, but it wasn't on. The window was open and I could see the trees outside. Suong was sitting on the bed nearest the window nibbling sulkily at one of the cucumbers she had bought from the old woman. The bluish bruise on her left cheek looked much worse in the electric light. Every so often she spat the cucumber skin onto the floor in short, sharp bursts. Ha was sitting on the edge of the same bed. As she peeled some of the potato-like fruit that Suong had bought, she glanced at me with shy affection.

Three flowers like Chinese bellflowers but with longer petals were arranged on the little table between the two beds. They were a mauve-blue color. A much paler blue than Suong's bruise. The glare of the electric light robbed the petals of their soft, moist sheen. It looked as though the flowers had been picked just below the calyx, and like decapitated heads with nothing

below the neck, there was something macabre about them. Now I knew what Ha had been doing by the pond.

Pushing in between Suong and Ha, Nyem sat down and lit a cigarette. With the cigarette clamped in his lips, he reached out his right hand, grabbed Suong's permed hair from behind and without warning yanked at it. The corners of her brown eyes were stretched upward. Her bruise changed to an ellipse the shape of Sumatra. Thrusting his nose up against Suong's, he screamed abuse at her. I sat on the bed closer to the door, wiping the sweat from my neck with my handkerchief and pretending not to notice. Ha came over and sat next to me. Nyem looked at me and said in English:

"She not just make mistake about sauna closing time. I give her money and let her negotiate, but she only get this room. She idiot, this woman—"

He was in the midst of this tirade when the naked light suddenly went out at the same time as a loud, dull *thunk* came from somewhere in the building as if someone had pulled a handful of thick rubber bands taut and sliced them in half. Power failure. Nyem went quiet. The tip of his cigarette became a red point of light floating in the darkness. It reminded me of his bloodshot eyes. Whenever the cigarette moved it left a red squiggle behind it. The shrilling of insects came in from below the window. I lay down on the bed and shut my eyes. I felt drowsy. Ha stretched out beside me.

How much later was it . . . ? A length of hair flopped onto my shoulder. Heavy. Ha was on top of me and trying to stuff the fruit she had been peeling into my mouth. The fruit broke up and I felt the thick, sticky juice flowing between my teeth and onto my tongue. From its appearance I'd expected something bitter but it was as sweet as a ripe persimmon. I opened

my mouth wide and took the whole fruit in. From their breathing I could tell that Suong and Nyem were asleep. Ha was saying something that sounded like the song she'd been singing on the straight road in the dark.

"*Honshiemu. Honshiemu.*"

Was it the name of the fruit? As I chewed and swallowed, I had a go at saying *honshiemu, honshiemu*. Lying on top of me in the darkness, Ha gave a nod and prodded my left cheek lightly with one finger. She wanted me to look over that way. My eyes were drawn to the little table beside the pillow. Something was glowing a faint, bluish white color. It was the flowers like Chinese bellflowers that she had picked at the edge of the pond.

The three flowers were slowly blinking on and off, not in sync, but one after the other. The mauve-blue petals looked moist and shiny, and every time they glowed feebly they turned the area around them pale blue. They were luminous flowers that glowed in the dark! Ha reached her white arm into the darkness. She moved the bell-shaped flowers, turning the inside of their bells toward us. There was a single firefly far down inside the thin petals of each one. Somebody had twisted together the petals at the mouth of the bell, and the fireflies, no matter how hard they tried, could not get out and were shining their lights in there.

I fell asleep again . . . We were rolling in single file along the straight road by the embankment—Suong, Ha, Nyem and I—all with the same kind of lice on our bodies. All four of us held blue flowers with fireflies inside like lanterns in our hands. We passed the old lady's tea stall. She waved at us. Her lamp, the same color as a Chinese lantern plant, receded into the distance and finally vanished in the darkness. We drove along the dark road in a single column with only the blue flower firefly lanterns to show us the way.

piano wire

a man I had never seen before was standing by the front gate of my house.

It was Saturday evening and I was on my way back from the high school where I taught art—I had just been supervising one of the after-school clubs there. I took a good look at him as I approached. From the main road I had turned left into our residential street where the thick foliage of the cherry trees formed a tunnel overhead, and I was only about ten meters away from the house. The sound of a piano filtered through the branches. Less than ten meters now. I recognized the piece as a Burgmüller étude. It had been Beyer till the day before. About eight meters away, I slowed down.

The plastic bag the man was holding bothered me more than his appearance. There was a paper bag jammed into his left armpit and he was clutching the other one protectively in both hands. It was this that caught my attention when I got closer. The man ignored me. It probably never occurred to him that the house was

mine. How else could he have stood there bang in front of the place, stock-still and without a word of explanation?

He put his right hand into the plastic bag and pulled out a small dark lump. I couldn't tell what it was. A pebble? He tossed it over the gate. I stopped in mid-stride. The lump must have hit the ground but it didn't make a sound.

There was a parking space just inside the gate, although we didn't actually have a car. I'd got rid of ours when the roadworthiness permit expired. There was now a scrawny and sickly duck where the car had been. I'd joined several sets of wooden slats together with hinges and propped them up against the gate to create an enclosed two-meter-square space for him to live in. The concrete floor was littered with droppings; it looked like someone had been chucking French mustard around. The duck's wings had turned the color of mustard from slithering about in it.

The duck had recently lost his appetite. We all thought he was dying. From where I was, I couldn't yet see him, but I could hear him quacking. He was obviously reacting to the man, or whatever had been thrown at him.

Now I could see the duck's head. He was pecking at the dark lump. His yellow bill was making a frantic rat-a-tat like a toy machine gun. Wasn't he supposed to have lost his appetite?

I came to a halt near the man. The two of us stood shoulder to shoulder in front of the stainless-steel gate. Again he dipped his right hand into the plastic bag. His slim white fingers closed on another lump.

"It's a cicada. This kind of duck likes cicadas, you see. But give it too many and it'll end up with tummy trouble, so today it's just getting three . . ."

The man whispered this to me without taking his eyes off the duck, then tossed in the second cicada. Waddling from side

to side on his sticky, inward-turned webbed feet, the duck shot over and picked it up with a bill that looked like a strip of plastic. I thought the cicada was dead but it gave a single short hiss like the noise of a hot rock being dipped into cold water. The man laughed just enough to stir the air around his mouth.

It was then I noticed that the cicadas were still singing in the cherry trees. And it was mid-September! The sound came pulsing into my ears in waves, drowning out the piano music.

The man's forehead was so high that his features seemed all crammed together in the bottom half of his face. His gaze was fixed and unblinking, making me wonder whether his eyes were locked in place, though they looked quite gentle beneath faint eyebrows. Maybe it was a trick of the light, but the irises seemed to be dark grayish blue.

"What happens at this time of year is that a lot of the cicadas who've lived a bit longer than normal start to die. You think they're dead because they're lying flat on their backs but they're actually in a state of suspended animation. There's some kind of nerve impulse they have that brings them back to life for a moment just before they die outright."

It sounded like he was reading from a text. He picked the last of the insects out of his bag and threw it in. His arms were surprisingly long. It must be quite a hassle folding arms that size. A faint, clean smell came from his gray summer suit.

"See that cherry tree over there—the one with one branch sticking out?"

He was looking up at the branch. His eyes were large but narrow. They really were gray-blue. There was something slightly feminine about his thin lips. I put his age at around thirty-five.

"I saw a cicada singing its heart out up on that branch a few

days ago. But its time was up and it fell off the branch and was crawling around near the duck there. And the duck gobbled it up, happy as Larry. That's why I got him three today."

"Him," eh? Clever he could tell it was a male. His getting the sex right made me want to tell him the duck's name was Castro—as in Fidel Castro—but I stopped myself. I was afraid he might take the opportunity to ask all sorts of private things about us.

Castro lifted his grubby head and began to swallow the cicada. The little lump slid slowly down his long, thin neck. Just before disappearing into the front of his chest, it gave another muffled hiss.

"Ah, I wish I could give him a proper wash . . . ," the man murmured to himself. Then, wiping his fingers on a white hand-kerchief, he waved to Castro and set off toward the little park in the heart of our neighborhood. Thrusting his beak between the bars of the gate, Castro quacked gently as he watched him go. The man's skinny gray back melted into the dusk.

He was bound to be back, I felt sure of it. I pushed open the gate and looked up at our gray house.

1.

The four of us were having a seafood casserole my wife had cooked. Each serving contained three prawns, two scallops and about one slice each of white fish—or at least should, my wife had told me. This probably meant there were a couple of polysty-rene containers which had held eight scallops and the white fish fillets lying in the sink together with the shells of twelve prawns and their twelve black intestinal tracts.

The heatproof glass pan my wife had used to steam the sea-food, and the pan in which she'd made the white sauce had been dumped haphazardly on the counter under the window behind her. Nekos, our tortoiseshell cat, was licking at the congealed sauce. The kitchen was full of the unwashed dishes from break-fast, not to mention all the stuff used to make what we were having for dinner—an egg whisk, an empty can of mushrooms, a bag of flour, a bottle of white wine, a carton of milk and so on—and they had ended up spilling over into the living-dining room as a result. It always happened like that.

Between the two pans stood a transparent vase. It had been there a while now. It contained five or six Mexican Asters, but the water had turned pale yellow and cloudy, while the autumn-flowering pinkish red flowers drooped wearily toward the table where we sat. Withered flowers and a pan encrusted with white sauce: the juxtaposition didn't strike me as the least bit unusual.

Faint and distant, the singing of the cicadas sounded like short-circuiting electricity. I steered our dinnertime conversation toward Castro the duck's eating habits.

"It's incredible. I mean, he'd completely lost his appetite. The idea of him being able to eat cicadas never crossed my mind."

The other three looked up from their seafood casserole as if their heads were spring-loaded. "And it was still alive? You're kidding," said my wife, sucking on a scallop. She had an oval face with a large, somewhat grayish nose. If you took a good look, you could see she had dozens of blackheads. The end of her nose was always sweating. Her hands, which were as round as bean-jam buns, were always clammy too.

Asagi, my eighth-grade daughter, frowned. Stabbing a prawn

with her fork, she waved it in front of her red-rimmed glasses like a little flag.

"I've read about it, actually. They taste the same as this. Fabre tried one, you know. 'Cicadas are perfectly edible. They taste rather like prawns,' he wrote. But what Fabre actually ate was the larva, though."

I too bit into a prawn dolled up in white sauce. I wondered if my wife hadn't perhaps forgotten to add the juice from the steaming process to the sauce. Or had she just steamed them too long? The prawn was dry and hard and couldn't compete with the toasty flavor of the grated cheese and the sauce. I had a feeling that this was probably what cicadas really did taste like. "Cicada casserole," you could have called it.

Asagi was something of an expert on animals. But though she knew a good deal about them, she wasn't any good at looking after them. None of us were.

"You want to get them in the summer," she continued, "when the larva's still in its skin and has just come out of the ground. It sheds its skin soon after that but they say it doesn't taste very nice once it's got rid of it. So you've got to catch 'em and cook 'em quick . . . Seems that Fabre fried the larvae. He ate them with his family . . . Said they tasted like prawns but were as chewy as old paper. He never actually recommended them to his readers."

Akane, my eleventh-grade daughter, joined in. She only began speaking after lifting her chin and rolling her eyes back in her head to reveal the whites. It always looked disparaging, but it was just a tic she had.

"The bodies of the adults must be harder than larvae, mustn't they? That means Castro could get serious digestion problems. He looked like he was at death's door in the first place, and now he's gone and eaten three rock-hard adult insects . . ."

In a small voice, her sister added: "It's amazing. For him to eat three of them . . ."

According to Asagi, there were two possible explanations for Castro having eaten the things. The first was that in his seedy state he'd known instinctively that cicadas would help cure him. The second was that he'd forced himself to eat to create the illusion of health and disguise the fact that he was sick. "It's called bluffing. It's common behavior in birds," she said, her cheeks bulging with seafood. "He was desperate, probably. He was putting on a show to protect himself from predators, pretending to be fine, like, 'Hey, look at me! See how much I can eat! Cicadas, sure I can eat 'em, no problem!' Poor thing, he'll probably get even sicker now. If he gets indigestion and can't keep bluffing, he could die."

Her voice was tearful though her mouth was crammed with food. Three forks—not Asagi's—abruptly came to a halt in mid-air. My wife, Akane and I all stopped chewing for a few seconds. We could hear the cicadas singing. Asagi was the first to start digging in again. Loudly. The three of us took this as a sign to resume our meal as well.

Asagi believed the second of the two explanations. Was the man who'd been standing outside our gate a hostile predator in that case? And was any enemy of Castro's automatically our enemy too? The memory of the tips of his long, pale, slender fingers clutching the cicadas came sinisterly to mind. I remembered his sad-looking eyes. There had been no hint of menace in those eyes.

Asagi was looking at me sternly.

"Who gave the cicadas to Castro? Three of them! Who?"

"Some thin, quiet-looking fellow. Don't know him from Adam. Never seen him around before. He went off in the direction of the little park. Wonder who he is," I murmured. As I was

speaking, the way he'd said, "I wish I could give him a proper wash," popped into my head.

I thought I should explain things to my daughter, slightly overstate the case, say "He didn't look like a bad man to me." But I stopped myself. I felt as though the piano music and the sound of the cicadas and the evening air had all passed clean through his frail, gangly frame. Had he really been there?

The singing of the cicadas had ceased. The cat leaped down off the sideboard. Something white and shimmery started drifting down behind Asagi and my wife. Dust. The seven decoy ducks arranged by size on the shelf above the window were clattering about and getting out of position. That's where the dust was coming from.

"Earthquake!" said either Akane or my wife. We stared at one another, clutching our forks. There was the muffled thump of falling objects.

The five air plants that were suspended from the windowsill by pieces of wire danced about, scattering the falling dust. Air plants are slightly creepy things that don't have roots. The leaves draw in moisture from the air so they're a cinch to grow. At least that's what my wife liked to tell me, but they never showed any sign of growth. The ends of the snakelike green stalks or the leaves—I'm not sure which—were all brown and dried up. My wife likes buying these things, but she's hopeless when it comes to looking after them.

The shaking continued. The water in the goldfish bowl on top of the stereo unit was sloshing about. There were three fantail Wakin goldfish in it, one of which was swimming on its side, though that had nothing to do with the earthquake; the fish was sick anyway and had white spots on its flanks.

The tremor stopped. From outside the window we could hear the cicadas singing loud and clear. The dust continued to drift down on us like bright toxic pollen from the shelf, from the air plants, from the second-floor ceiling of the loft-style kitchen.

"I'm going to keep an eye on Castro tonight."

Asagi suddenly began talking about the duck as if there'd never been an earthquake. "Me too," Akane chimed in, and as my wife brought a piece of the now lukewarm food up to her mouth, she agreed that it sounded like a good idea. There was dust in the casserole we were eating.

Things that have fallen over ought, in theory, to be tidied up. A one-liter carton of Tropicana 100% juice lay at Akane's feet, with the illustration of a juice-oozing orange uppermost. By the carton on the floor lay a few insert ads from the newspaper—"Recruiting Executive Members," "Model Apartment Now Viewing," "Men's Clothing: Special Sale"—along with direct mail from a department store, the evening edition of the *Mainichi Shimbun* paper and—what was that?—yes, half a broken Glico Marble Pocky chocolate stick. They had all fallen off the sideboard in the earthquake.

Akane lazily stretched a bare foot out from under the table and pushed the juice carton thirty centimeters off to one side.

I glanced at the sideboard. There was a plastic bag of toilet paper with "12 Rolls" printed on it. The mouth of the bag had been stretched just as far as it would go and ripped open. About three rolls were gone. Someone had put the evening paper with all the loose ads in it on top of the unstable pack of toilet paper and then gone and balanced the juice carton on top of that. It wasn't surprising that they'd all slid onto the floor. But I'd no idea what the broken stick of chocolate was doing there.

But then doubt crept in. Maybe the things hadn't actually fallen in the first place? It seemed safe to assume that they had, yet I couldn't actually remember where they'd been before falling down. And the reason I couldn't remember was because things were in more or less the same state before the earthquake as they were now when the shaking had completely stopped. For all I knew, the chocolate stick and the insert ads and the juice carton had all been down on the floor to begin with.

Only one thing, I thought, was crystal-clear. The *Mainichi Shimbun* was not today's paper; it was from several days ago. After getting home, I had come across today's paper turned to the TV listings spread out on the floor of the downstairs bathroom.

In this house, there was always stuff lying around all over the place. Clothes lay on the floor of the living room like lumps of cow dung, while paper, cardboard boxes, dry cat food that Nekos had left uneaten, candy wrappers and wire coat hangers proliferated morning, noon and night. We were simply incapable of tidying all this stuff away properly. Worse than that, things would spring up and flourish like tropical plant life before we could even get around to tidying up.

This sort of thing no longer bothered me. I didn't just not feel annoyed, I didn't feel depressed, either. And I didn't just not feel depressed, I didn't feel hopeless or futile. Probably it was because I'd realized it was easier that way. But sometimes I did feel a bit frightened.

After dinner, we all went out together to the covered parking space to have a look at the duck. The cicadas in the cherry trees were still singing away. Castro emerged from inside the big birdhouse in the corner of his enclosure quacking softly from

the back of his throat. He went up to Asagi, waddling from side to side. Asagi spread her arms wide to receive him. As she cradled Castro's dirty head, she told him off. "Castro, you mustn't eat cicadas. Anyone who tries to make you eat cicadas is a nasty man. And there's no need to put on a performance for us, pretending you're fine like that. You need to take it easy and rest."

The duck slipped his head out of her grasp then knocked his bill against the lenses of her glasses. I went into the enclosure and shone a flashlight onto the concrete floor. I almost lost my footing on the moss and the mustard droppings.

I tried imagining what color a duck's feces would be after he had digested a cicada and discharged it at the other end. I already had my doubts about the ability of this duck's stomach to break food down. I usually gave him wheat bran and fishmeal with lots of water mixed in, and when this came out it was so little changed you could easily confuse it with the original food. The bran was a little gooier but the color was much the same. My guess was that the cicada-based droppings were going to be a brownish color too, with fragments of meshed wing and eyeballs like black beads that would give off a glittering reflection in the circle of light from my flashlight.

But there was nothing glittery like that at all. Egged on by Asagi, I shone the flashlight on Castro's bottom. It was just the usual grubby brown color.

"Doesn't look like he's got diarrhea," said my wife cheerfully. The woman was an incurable optimist.

"Maybe he's constipated? Clogged up . . . ?" suggested Asagi apprehensively.

"Do you think he could have just pretended to eat them?

Birds can be good at putting on an act, but would they take it that far? But, dead cicadas . . . I can't see any dead cicadas anywhere." Akane was talking to herself, with her chin thrust out, as if she couldn't believe what I had actually seen.

A leaf from one of the cherry trees was floating on top of the duck's pool. We used a plastic clothes drawer for a pool, but as we hadn't changed the water for days and it was muddy-brown from all the duck shit in it there wasn't much chance of our spotting anything unusual. At our house, even our best efforts didn't make detecting any sort of change easy. I gave up and switched the flashlight off.

The cicadas were rasping in the cherry trees. Several of them were jetting about in the darkness like lunatics. They turned into little black missiles, hurtling like crazy cartoon figures until they bumped into something and crashed to the ground emitting a shrill, staccato scream that scorched the darkness. Then they lay there in "suspended animation," as the man had mentioned.

When I got into bed and closed my eyes, I saw the gray-blue irises of his eyes. He was holding a cicada as delicately as a piece of chocolate, and his nimble index finger and thumb wriggled white against the darkness . . .

A thunderous roar came toward the house. The windows vibrated. It was the biker gang that since the start of summer had been having its nighttime get-togethers once or twice a week in our little local park. Ten bikes, maybe fifteen. Usually they did a wild circuit through the residential streets where everyone was trying to sleep before disappearing off somewhere on the other side of the main road, but tonight the roar came to a halt in front of our house. They parked their bikes just by our front wall, engines still running and throttles wide open.

Should I go out and speak to them? Tell them to stop it? I couldn't make up my mind. I heard the sound of harsh laughter. I held my breath. They didn't seem to be speaking Japanese, but some horrible, screechy foreign language. I imagined them all with braces on their teeth; the twisted wire crammed into the mouths beneath their helmets, completely covering their teeth and glittering as they spoke; the clacking of metal on metal whenever they opened or closed their mouths.

The roar built up to a crescendo. I heard more laughter that sounded like metal being scraped. The throbbing engines moved away toward the main road. Their tires must have crushed lots of cicadas lying there unconscious. Each time a cicada was squashed, it let out that shrill, staccato scream.

2.

We lived in a two-story house as flat and featureless as a warehouse. It was over ten years old, but I didn't want to move because the rent was low.

The walls were a drab gray and it had no balcony or bay window to provide a visual accent. If not a warehouse, then it was most like an overgrown police box or the sort of housing for security personnel they have around Narita Airport. This was because it had blank, expressionless walls made from bolt-on cement boards. My wife's uncle, who was the landlord, told me that they were called "cement sidings" and were certified as a fireproof building material by the Ministry of Construction (No. 254). The house was so sturdy-looking you felt tempted to lob a Molotov cocktail at it just by way of an experiment. I suppose it was built as a rental property with durability—and nothing else—in mind.

The only element to suggest any individuality on the part of the owner was a row of six round windows up on the second floor which made the house look a bit like a beached ship. Most of the other houses nearby were nicely designed, with white or beige walls, frames around the windows, and mansard roofs; this just made our place stick out like a sore thumb, as if it had taken the perverse decision to be as dreary as it possibly could.

The morning after the day Castro was fed some cicadas and there'd been an earthquake, Asagi—who had gone to the 7-Eleven to buy some Merita coffee filters—came charging into my room shouting at the top of her voice. She'd discovered a huge bit of graffiti in English, she said, on the wall of our house.

"I know graffiti's graffiti, but this one's just so cool."

She was much more excited than disapproving. Our house stood on a corner and its walls faced right onto the road, meaning it was easy enough to spray them with graffiti over the fence, which was only about waist high. Someone must have climbed up onto the fence to do this particular piece of work as the letters snaked high across the wall like a brand-new signboard. Done in red spray paint, it was as long as the distance from one hand to the other if you spread your arms wide.

RUBBISH

The letters were bright and vivid against the depressing ashen gray. It looked like they'd gone over it two or three times, as bright red drops left meandering trails down the wall beneath the seven letters. It was an impressive sight.

"It's cool, isn't it? Like the logo of a funky club. It'd look even cooler if you added a black outline to the red, I bet."

Asagi's myopic eyes gleamed behind her red-framed glasses

as though she'd just been kissed by her favorite TV celebrity. Her round face was red and flushed with excitement.

"It's like the title of a horror movie."

Akane wasn't particularly critical, either. It must have been done by the bikers who had been parked in front of the house last night. Looking around the neighborhood, I was peeved to see that ours was the only one to have been vandalized. Had the wall's bare-faced ugliness provoked those kids with their raspy voices?

"Bet you there's a guy nicknamed Rubbish in that gang."

That was Akane's theory anyway, but my sense was that they had seen through to what the place was like inside and labeled the whole thing as "rubbish"—which was right on the mark, though admitting as much was uncomfortable. It was as if the whole house was proclaiming to the world that it was a dump. Annoying, definitely, but somehow in my heart I felt we had it coming.

"Hmm, I wonder if we should report it to the police. How do you think we can wash it off . . . ?"

My wife sounded quite unflustered as she stood there looking up, with her arms crossed.

"Go to the police and the gang'll be back for revenge," Akane replied. "Why not leave it? It looks cool."

"Yeah, nothing wrong with an ugly house like this getting a bit of decoration," said Asagi.

In the end we'd probably not get in touch with the police or clean it off, either. That was my opinion. Taking action wasn't exactly one of our strong points. My feeling was that if we'd been more effectual generally, no one would have spray painted our house in the first place.

Somebody had thrown five empty coffee and soda cans over the fence onto the weeds directly under the RUBBISH graffiti, and there were cigarette butts scattered everywhere. Must have

been the bikers. The empty cans had all been crushed flat. Did bikers have a crippling grip? Perhaps they'd crushed the cans like so much paper as they held them, the wire in their mouths clattering against the rims of the drinking holes.

Late-dying cicadas shrilled away in the cherry trees. The volume of the sound seemed a little lower than yesterday.

As the four of us with me leading the way turned our backs on the wall and headed for the front door, a shadow like a bundle of black cloth suddenly skimmed over our heads and fluttered down into the garden by the parking space. It came with a whooshing noise and a slightly rank gust of air on our faces. We cowered, rooted to the sidewalk. The duck gave a shrill squawk and dashed this way and that, flapping his wings. It was a crow. The crow touched down, picked up a triangle of wire in its beak and flew off immediately.

"It's a hanger. A wire hanger that'd fallen into the garden. He's gonna use it to build his nest. They stick the hanger between the tree trunk and a branch and build their nest on top." Asagi was pointing up at the sky. There were always things lying around in the garden at our house. "A while back one came and swiped a pair of Akane's panties that had fallen off the washing line."

My wife, Akane and I stood with our mouths open looking where Asagi was pointing.

Holding the question-mark-shaped part of the hanger in its beak, the crow was thrusting upward with its thick neck and gaining height. The triangle hung in the sky, swinging from side and side below that evil-looking face and its molting black feathers. The bird moved farther and farther west. Our gray, two-story house stood far below. Either us or the crow, I thought, has got to be dysfunctional. The four of us stayed there staring at this bizarre flying object.

• • •

We were a slovenly family.

Each had an individual character, but we were remarkably similar when it came to being sloppy. Sloppiness was something we excelled at. I'm ashamed to admit it, but our house was an eyesore inside and out. Given four people, you'd think that at least one of them might actually like tidying up, but for some reason none of us did.

We had discussed this problem of ours thousands of times. We had yelled, cried, even physically fought with one another as we talked it over. Then, somewhere along the line, we got so sick and tired of discussing our sloppiness that it became taboo, a topic equally unpopular with all of us. It made no difference how many tens of thousands of times we discussed it, we were incapable of mending our messy ways. Had any member of the family tried to bring up the whole business again, that person could be sure of being treated like a leper by the rest of us.

Let's imagine, just for the sake of argument, that one day I straightened my shoulders and said: "I really think we should all have another go—just this once—at talking this through. How about us all trying to make a fresh start, eh?" How would my wife and children react? I could picture it clearly. The three of them would turn around together deliberately slowly and look at me, as though they'd choreographed the move in advance. Or they'd stare up at me quizzically. Look at me as if I were some kind of sea slug. Then with exaggerated weariness, they'd chorus, "What's wrong with you, Daddy? Has something happened?"

The issue had been analyzed so often that it had passed beyond being a rectifiable problem anymore. Oddly enough, giving up didn't feel too different from sorting it all out. I thought

we were a happy family precisely because we didn't give one another a hard time for being messy. That's not to say, of course, that I was completely satisfied with the present state of affairs. I guess I thought that maintaining the status quo—despite knowing it had to break down someday because it was just too eccentric—was the key to a quiet life. Yes, we were slobs, but the living was easy.

That evening, Asagi realized she had left her lunch box at school the day before yesterday, a Friday. By her usual standards, this was a quick reaction. My wife informed her that her elder sister's lunch box was sure to be in the house somewhere. Akane didn't go to the private school where I worked, but to a prefectural school that was unusual in having not just a school shop but a dining room where meals were served. As a result, she hadn't had packed lunches since leaving junior high.

Akane's tic was playing up again. Sticking out her chin, rolling her eyes back to reveal the whites and pulling a face, she thought deeply before giving a brisk nod and rushing upstairs to the girls' room. She didn't come back for half an hour. Their room was such a crush of heaped-up magazines, school uniforms, underwear, CD cases, chocolate wrappers, dolls, posters and even, believe it or not, tampons that not a single square meter of the wooden floor remained uncovered.

Akane came down the stairs, blinking repeatedly and occasionally rolling her eyes. She was holding something wrapped in a check handkerchief as reverently as a precious scroll.

"It's been hibernating for a year and a half," said my wife.

At times like these no one criticized or made fun of anyone else. "Been hibernating for a year and a half" was a straightforward emotional response to the fact that the lunch box, which had been

brought back from school and then left unwashed, undiscovered and unopened for eighteen months, had been there in the girls' room all along. I sensed a touch of regret mixed in with surprise, but my wife's remark was mainly an uninflected remark about the presence of something and the passing of time. I suppose it was the kind of attitude that you could only acquire after discussing the big issue in depth and from every possible angle.

My wife had once made the mistake of putting the TV remote into Asagi's lunch box instead of her chopstick case, but the rest of us were guilty of numerous similar mistakes.

"I'm going to open it, okay? See what it's like inside," Akane said calmly as she put the box down in the center of the table and began unwrapping the handkerchief.

The four of us formed a circle around it. From beneath the cloth there emerged a small black plastic container with a picture of Snoopy on it. Akane tried her best, but she just couldn't prize open the hermetic lid. The lunch box ought to have been empty and the lid flat, but it was bulging slightly as though pushed out of shape by an extra large serving of rice inside.

"It's gone all virginal. It doesn't want anyone forcing their way in!" joked Asagi.

Replacing Akane, I grabbed the box's clasps. With the three middle fingers of each hand, I tried to wrench off the lid, which felt as though it had been welded on. Asagi whispered: "The box is saying, 'Ow, you're hurting me!'" The lid came off with a shy little pop. At the same time, a cloud of smoke rose unexpectedly out of it. The smoke was like dry steam. Mold spores.

"Help, it's Pandora's box! Open it and we'll all get a year and a half older," shrieked Asagi, coughing on the spores. The smell was surprisingly straightforward and inoffensive, like flour that had completely dried out. I wondered if the contents of the

lunch box would be recognizable, and if green peas—Akane's favorite—would be in there; but there was only a small round tinfoil dish with mold in it. The mold stood bolt upright and shone like thousands of pins in a pincushion, but the pins buckled and turned into a fine layer of powder on the bottom of the box within a few seconds of my opening the lid. Or so it seemed, for an instant later it had changed again, this time into a pale purple smoke that covered our faces as we gawped down at it. My family's mold-dusted faces smiled weakly.

I could see my wife's fleshy nose through the rising smoke. Each of the individual droplets of sweat on it was coated with mold. Naturally enough, I hadn't let her in on this, but one reason I had married her was my belief that the moist tip of that nose of hers was a sign of good nature. Later I had revised that opinion, and now saw it as just a sign of sloppiness instead. That was the thought that came to me amidst the mold dust.

3.

The sound of the cicadas was getting quieter every day, but it hadn't yet completely died out. The vivid red of the RUBBISH graffiti still stood out like a neon sign against the gray wall, unwashed and unreported to the police. I did actually start dialing their number before realizing I had no proof that the bikers in the little park were responsible. Also the thought of having to deal with the police on a matter like this—especially with me being a teacher—was actually more depressing than the bother of the graffiti itself, so I gave up on the idea of notifying them. As you can see, my family and I were past masters at devising reasons why doing nothing was okay when confronted with the choice of whether to take action or not.

I was busy preparing some art exhibits for the school arts festival, so got back late on the Saturday one week on from when I'd seen our duck eating the cicadas. Castro was quacking away in the darkness and, as I rang the front door bell, I was thinking how well he sounded. The door opened and Asagi, a flashlight in her hand, shot out, almost colliding with me. "Look, look, look," she yelled three times in succession.

Inside the ring of light cast by her flashlight stood an immaculately white Castro. It was as if the feathers on his tail, chest and neck, which had been all matted and brownish with his droppings, had grown anew; even without the flashlight, his luminous whiteness was visible in the darkness like an afterglow.

"Someone washed him for us. It was the guy you told us about, Daddy, you know, that one . . . the cicada man. Just look how clean he is!"

So he had come. I thought he would.

Asagi shifted the circle of light to the pool. Refracted in the clear water, the orange-tinged light quivered on its pale green plastic bottom. It wasn't just the water that had been changed, the black mold, together with the undigested bran that had encrusted the bottom of the pool, and the moss on its outside— all of them had gone without a trace.

Washed clean of molted feathers, droppings, tubifex worms and slugs, the concrete floor smelled of fresh water, too. The green moss that had been growing on the wooden boards had been carefully scraped off. Asagi shone the flashlight on Castro again. He seemed to be a completely different species of duck. With his brilliant white costume spotlighted like a stage performer, he even looked a little cold.

My wife explained: "'If it's all right with you,' the man said, 'I'd like to give him a wash.' He wasn't being snide or anything.

His name's Mr. Mikami. I couldn't say no to someone with such nice manners. Asagi gave him a hand, but he'd even brought a deck brush and a scrubbing brush along and, well, he cleaned the whole place up just beautifully." The way she spoke about it, it was as if she were the one to have been washed.

And it wasn't just her. Akane and Asagi also seemed to feel they had undergone some sort of freshening up. I was glad to hear it. You couldn't say that our attitude to messiness had changed; it was just that it actually felt nice to be clean and tidy. Somewhere, deep in our subconscious, we must have had a hankering for cleanliness.

With the sense of having gained a new insight into our feelings on the matter, I walked into the house and was confronted by God knows how many pairs of sneakers, men's shoes, high-heel shoes, basketball shoes and tennis shoes, all lying like so many hunks of moldy bread where they'd been kicked off—don't ask me why, but one of them even had a fifty-yen coin inside. As I waded into the living room, fighting my way through the flood of old newspapers, loose ads, odd socks, empty KFC boxes, life insurance pamphlets, sponsored packs of tissues and direct mail that littered the floor, I told myself that the problem wasn't that we didn't want things to be clean and tidy, just that we weren't naturally methodical, so that even if we did manage to do something about it, we would never keep it up long-term.

I admit that I felt well-disposed toward this man who had cleaned up a pet and part of a house belonging to someone he didn't know, despite having no obligation to do so and receiving no remuneration, but there's no denying that it struck me as odd. I wouldn't say he was too good to be true, any more than we were too bad to be credible, either; but it still didn't seem quite

right somehow. Gleefully the three women told me more about him. Asagi in particular was very excited.

"We sorted out the cicada thing. He said there are still people in some places in the world today who eat cicadas and their sloughed-off skins, so it wasn't just something people did in the old days when Fabre was around. He said there's no way they could harm a duck because they're quite common as a kind of medicine . . . He went to vet school. Apparently Castro might have a disease called bumblefoot. He's going to come back tomorrow morning and examine him properly. He's a nice guy. Not a baddie at all, not in a million years!"

My wife told me that the man had recently moved here from Tokyo and lived behind us near the small park. After tidying up the duck's enclosure, he'd gone straight home, without dropping in to our place.

Thank God he hadn't come in. It would probably have antagonized him instantly. I remembered those long white fingers of his holding the brown cicada.

"We ought to invite him in when he comes by tomorrow, don't you think? A cup of coffee's the least we can do," said my wife.

"Yeah, you're right," I agreed.

She gathered up the washing, the blankets that had been hung out for airing several days before, the ironing board, Akane's dark blue coat which had been hanging in the room since early spring, the empty box for the word processor I'd bought, the children's training pants they'd shoved under the sofa, and all the other junk in the living room and lugged it into her small tatami room next door, the way she always did the night before we were due to have a visitor.

She also picked up several pairs of "spectacles" which had been abandoned in the corridor leading to the bathroom and the

toilet and put them in her room without spoiling their shape. Jeans, men's dress trousers, women's slacks—peel them straight down from the waist and step out of them, and you're left with two circles on the floor. It was Asagi who had christened them "spectacles," and in this house there was never a day without someone shedding a pair somewhere in exchange for a new one. The girls had come up with the name "bifocals" for when your underpants made a second set of circles inside the original pair. I'm sad to say that it was perfectly okay to let a few days pass before you stuck your legs back into these "spectacles" and pulled them back on.

Thanks to all this, the door to my wife's room, which had already been a mess anyway, was bulging with the pressure of all the stuff on the other side. We were now as ready as we'd ever be to invite Mr. Mikami in.

In the middle of the night I was woken by the sound of motorbikes again. The roar was coiled up right by my ear. Mixed in with the heavy throb of the engines were those voices that sounded like sheet metal tearing. They were calling someone's name. Was one of the kids with his bike parked under the graffiti saying something up to the round windows on the second floor? Was Akane sticking her head out of a window to talk to him? Was she looking all flirty and using filthier language than I'd ever heard from her before . . . ?

As the fantasy grows, I'm finding it hard to breathe. An illogical hatred of the bikers wells up inside me, intense enough to make my throat hurt. Eventually, the roar begins to move off and recedes into the distant darkness like a python dwindling away to a tubifex worm. In its place I can hear the duck quacking softly to himself.

I go downstairs. I pick up the phone on the sideboard. The phone cord and another cord coming out of the wall are as black and tangled as a heap of squid-ink spaghetti and I can only get the receiver up to hip height. If I want to make the call, I'll have to lean right down to put my mouth and ear to the receiver. I don't fancy calling the police in such a position. I abandon the idea.

I open the refrigerator to help myself to a beer. Left over from dinner two weeks ago, a plate of pork belly with daikon radish sits lopsidedly on top of some beef cooked in soy sauce that has been living in there for several months now. The fat has congealed and turned white, making it look like one of those replica meals made of wax. Beside it an open tube of QP Mayonnaise lies on its side, while some marinated pollock roe is breathing its last beneath it. At the back of the refrigerator some chicken wings beg for my help, thrusting their white stumps toward me between a long-forgotten bottle of seasoned bamboo-shoot sauce that has gone bad and a packet of mold-covered sea urchin.

It was just like that Géricault painting, *The Raft of the Medusa*. Naked bodies sprawling on top of one another on a raft; some sick and on the verge of death; others waving feebly across the swelling sea; the clouds like blotches of black mold, the sail about to split . . . From inside the refrigerator I could just catch the sound of groaning. I slammed the door shut.

I thought about Mr. Mikami. The thought was refreshing, like feeling water trickling down one's throat into one's stomach. Was Mikami going to ride to our rescue? Turning this over in my mind, I drank my beer and then quickly went back to sleep.

4.

The next morning Mr. Mikami came striding along the avenue of cherry trees in a white polo shirt. From both sides the branches stretched over his head and the densely layered leaves splashed his shirt with green light. The Burgmüller étude *Innocence* came filtering through the foliage. The right hand was still too stiff to play the *legato* runs of eighth notes and they sounded lumpy. Now and then the piano would drown out the shrilling of the cicadas. As the man marched toward me as briskly as a race walker, with his back quite straight, the piano study and the singing of the insects seemed like the overture for his appearance onstage.

I was out by the gate and feeling a bit depressed after finding a new batch of cans and cigarette butts lying discarded under the RUBBISH graffiti when I spotted our visitor coming. He had some sort of paper package under his arm. His white teeth were visible though he was still a good way off. I ran back inside and called the others, conscious that my voice sounded shrill and anxious.

"Mr. Mikami's here!"

The three of them came rushing out. The duck also craned his neck in anticipation. We received our visitor like sick disciples welcoming the revered leader of their sect to their home.

For the next two hours, he worked as though he had come to perform an exorcism.

"I'd like to wash the place again," he began.

So saying, he rolled up the bottom of his jeans, took off his socks and got going. He emptied the water—which wasn't really all that dirty—out of Castro's pool, and gave the pool, the concrete floor and the wooden slats a good hose-down. A mini rainbow stretched from his hand to the gate, and the duck went in

under the arc and flapped his wings there happily. Drops from the transparent, purplish rainbow bounced off his feathers onto the ground.

The sound of the piano came from the avenue of cherry trees. It was the first eight bars of *Innocence* being played over and over. The playing sounded better than it really was because the drops of water off Castro's wings seemed to coincide with the eighth notes: G-E-D-C. G-E-D-C.

Castro waddled over near Mr. Mikami's hand and, opening his yellow bill wide like a pair of chopsticks, tried to catch the end of the rainbow in his mouth. The duck must have been laughing deep inside his belly.

I thought Mikami had already finished the job with a deck brush when he squatted down and gave another good scouring to everything between the food tray and the pool with a scrubbing brush that made a satisfying sound; he then looked up at Asagi who was standing by with the hose and said in a pleasant voice:

"Okay, give it another squirt, please."

Asagi, who had decided to go barefoot somewhere along the line, sent a jet of water from the hose together with a stream of slime like a mixture of viridian and midnight blue paint sweeping down the gutter. The place had been that filthy! The smell of food pellets and duck droppings vanished and only the smell of water remained. The stains on the concrete floor disappeared completely, leaving it wet and gleaming and almost white.

"Right then," said Mr. Mikami to no one in particular. Then he blew on the tips of his long white fingers and did something that seemed like a conjuring trick to us, despite not being very remarkable at all really.

He slowly unwrapped his paper package. A rolled-up, dark green sheet of plastic, like a car floor mat, emerged. Mikami

went into the duck's enclosure where he unfurled the plastic with a single brisk movement as though displaying a bolt of cloth on a tatami floor.

"Is it all right to put this down here?" he asked, after fitting it in place.

It was synthetic turf. The reverse side was dark, but the surface was covered with short plastic blades of grass that were shiny and in a shade of green that shouted, *Look at me! I'm green!* The size of a small rug, it covered the space from the birdhouse to the pool. The green was actually easy on the eye. Pure white Castro climbed up onto the turf, then shook himself and started to strut about with the self-importance of a VIP. Akane shrieked with delight, followed by Asagi. My wife started to clap, then the rest of us joined in.

"I picked it up at a gardening store in Tokyo. I've been wanting to do this for a long time," said an emotional Mr. Mikami. Castro, he explained, had been in danger of getting a disease called bumblefoot. Walking on concrete had worn away the skin on the underside of his webbed feet, particularly around the heel, which looked as though it had been filed down, and he had developed an ulcerous scab.

"All sorts of minor germs had got in that way and that had weakened him, but you saw the effort he made to get the nourishment he needed: eating the cicadas on the ground—and I gave him quite a lot myself, actually . . . Anyway, concrete's really bad for him. That's why I brought over this artificial turf. It's also easy to clean . . ."

Mikami gave Asagi the duck to hold. The webs on both his feet were worn so thin that the sunlight passed right through them, while the horny part at the back, his heel, was worn away, and, sure enough, he had a corn-like ulcer there. I felt a bit

shaken. It was our laziness and our indifference that slowly but surely had eaten Castro's webs away.

Mikami applied some ointment to the ulcer with his pale fingers, murmuring, as if chanting a spell, that it was a compound of dimethyl sulfoxide and dexamethasone. One of Castro's eyes was looking at me as this was being done to him. What was he thinking? His gaze was cold and penetrating. It always was. The rim around his black eye was indigo blue. This, it occurred to me, was the same color as Mr. Mikami's irises.

The latter came into the house for a cup of coffee, but he didn't seem able to sit still. He looked fidgety and, sure enough, it wasn't long before he announced somewhat apologetically that he would like to change the water in the fishbowl, if that was all right.

"I'll need to let the water stand awhile to get rid of any chlorine. Have you got another bowl?"

The expression on the faces of my wife and daughters seemed to say: What kind of magic is he going to show us next? They dug out a bowl used for washing vegetables from the heap of things in the kitchen, then all four of them went out to the porch together.

I could hear Asagi's enthusiastic voice. She was explaining how she had won the duck and the goldfish in a two-hundred-yen-a-ticket pet lottery at a temple festival, while Nekos the cat had originally been a stray but had wandered into the house and become our pet . . .

"In a pet lottery, you see, all the tickets come with prizes. Ducklings are No. 2, quail are No. 4, and goldfish are No. 6—that's the lowest one. So, you see we've raised Castro since he was just a teeny duckling. Two years ago he was this small—just an unbelievably tiny little baby. The quail was eaten by Nekos in

no time. And one of the fish we won in a recent lottery isn't in great shape . . ."

"I suspect he was probably sick when you got him. What he's got is something called White Spot," Mikami said. "There's a nasty little parasite called Ichthyophthirius that's attached itself to him. I'll bring some medicine next time I come around."

With the goldfish sorted out, next up were the air plants that were suspended on wires from the windowsill. "This just won't do," he muttered and, taking all five of them off the sill, he carried them out to the porch where he blew on them hard to get rid of the dust. The three women trooped after him and began to water the plants as he instructed.

I waited for them in the living room. I could hear their lively voices coming down the hall. From beyond them came the sound of someone stumbling through the piano study. A pleasant Sunday.

"Water them once a week or every ten days . . ."

That was Mr. Mikami.

"I don't think we've done it for about three weeks!"

Akane.

"This thing like an octopus's tentacle sticking out of this young one's head, that's xerographica . . ."

"No, not psero, xero . . ."

Mikami and my wife.

"What's this? This thing like a ball of grass?"

Asagi.

"I think it's bergeri. The one next to it's streptopharagus. I have one too. See how it's got no stalk. Just leaves . . . Have you ever touched it? No, not like that. Touch it so you can really feel its texture. Slowly, slowly . . . with the pad of your finger."

Him.

"Like this, you mean?"

My wife? No, maybe Akane. Their voices sounded the same to me.

"That's it. That's right. What do think? Like velvet, isn't it? I like to touch it after I get back home in the evening and I'm alone. It's soothing. The calm seeps in from the tips of one's fingers . . ."

Him.

"More like buckskin than velvet, I'd say."

My wife. She sounded absurdly girlish.

"I know. It's hard to believe, but these ugly leaves can actually produce deep purple flowers. You never know what kind of flowers you're going to get till it's budded and blossomed, because the people in the flower shop don't know themselves."

Mikami.

"I wonder what color this one will be?"

My wife.

". . . I'm not sure, but I think it puts out a bright red flower at night. So red you can see it in the dark. I'd like to see it myself."

Him.

I started nodding off.

Extraordinary really. It was as though I'd been used to the sight and sound of him for ages already. His voice had no sharp edges. He spoke slowly, but smoothly, fluently. Most visitors couldn't conceal their shock at the chaotic state of the house and it came out in their voices, but Mikami was so unfazed it was as if he'd known what it would be like all along. He wasn't hiding anything. We could all spot a faker straight off. Just because we're slobs and our house is a mess doesn't mean we don't have any feelings. On the contrary, we were acutely sensitive to any change in our visitors' manner. We would realize

they weren't being completely honest, then they would realize they'd been found out, and the whole thing could become quite awkward. So sometimes both we and our guests would be busily pretending we hadn't noticed anything amiss even when we had. We didn't have that trouble with Mr. Mikami. Why, I wonder?

That day Nekos, our cat, ran away from home.

5.

It was the end of September and Nekos had still not come back.

Mikami stood in a pale blue polo shirt on the roof of our house waving at us with one hand. A typhoon had just passed over and the sky was extraordinarily clear. His arms, long and white as the branches of a silver birch, looked cold. But he was an impressive sight nonetheless. He stood there indifferent to the height and pitch of the roof wearing an expression that suggested he hadn't used a ladder to get onto the roof, but had floated gently down to it from the sky. The sound of the piano lesson nearby was sharper and more metallic than usual.

The four of us were looking up at him from the street and waving back. The duck, whom Mikami and Asagi had recently washed, was standing near her peering up at the roof with his neck tilted to one side. When ducks look up they don't just lift their bills straight up: they tilt their heads sharply—as if rather dubious about things—and look with one eye pointing upward.

Mr. Mikami squatted on the roof, an intent expression on his face. Then he knelt down, one knee on either side of the flaking green tiles of the roof ridge, and pressing down with the crotch of his jeans, crawled toward the TV antenna which had fallen over in the previous night's storm.

Being afraid of heights, I had been planning to get an electrician in to fix it, but Mikami pushed ahead regardless "because little Asagi here's desperate to watch TV." He'd dug a two-stage extendable ladder and a pair of pliers out of the assorted junk in the storage shed, and climbed up onto the roof.

His bottom looked very bony up there. He was a tall man, but he might have been made of glue and paper. If he slipped and fell to the ground, he'd probably not make much of a noise.

"The—wire—has—snapped. It—was—rusty."

The way he shouted we could have been a hundred meters below him.

"Be—careful. Don't—fall," my daughters shouted back hammily. We were as excited as if we were celebrating the raising of the ridgepole.

Laying the antenna flat on the roof, he replaced the three wires closest him with some piano wire he'd come across in the storage shed, then took hold of the antenna and stood up. The new wires duly lost their sag; they went taut and quivered with a rhythmic hum, stretched tight across the blue sky. Down below we applauded, and Mr. Mikami responded by making an okay sign with his thumb and index finger. Then he changed the three longer wires that went from the ridge of the roof to the eaves and back. Finally, he grasped the antenna with one hand and shouted down to us:

"Is it straight?"

"Yes, it's straight," the four of us yelled in unison, and Mikami struck a pose. He plucked at one of the thin steel strings stretching across the sky like a bass player and when it produced a clear, dry, twanging sound, gave a deep bow as if to say, Ladies and Gentlemen, the show is over.

On the side of the wall about midway between his feet and us the seven letters of the RUBBISH graffiti stood out in garish red.

Beneath it was the usual litter of empty cans and bottles. Mikami squinted at the graffiti as he made his way down the ladder. We could overhear him saying: "I'd like to clean that off. Thinner would probably take care of most of it, but there'd be traces left."

He got off the ladder, looked up at the spray paint and then said, as though talking to himself: "If there are going to be marks after I clean it off with thinner, then I suppose I could just paint the whole wall. Some nice bright color. A lot of the paint's come off the roof, so if I repainted that too, the house would look fantastic . . ."

My wife and I looked at one another; Akane and Asagi did the same.

For some time after Mr. Mikami had begun dropping in on us, there had been no change in our incompetence at cleaning and tidying and we were just as slovenly as ever. With the exception of brand-new socks, I had never worn a matching pair in my life, but would head out of the house with whatever my wife had handed to me, usually odd ones though of a similar color and pattern. Akane and Asagi were quite happy to wear white socks of different sizes and styles too.

When Akane got back from school she always went into the living room with its accumulation of insert ads, clothes and paper packages, fixed her eyes on the cake on the table, dropped her bag on the floor with a thump as if all her finger joints had suddenly dislocated and sat down, her expression vacant and her eyes staring. That habit hadn't changed.

Stuff kept proliferating. Direct mail fliers from department stores and cram schools printed on high-quality glossy paper with a razorblade-like sheen slid relentlessly into the house through any available crack. To me they seemed like blackmail notes that said, We won't stop coming until you give in.

There was no change in my wife's habit of dumping the plastic bags full of shopping from the supermarket on the table and then forgetting all about them.

I was aware that all three women had been sharing one another's panties for about a year now, and that didn't seem to have changed, either. In the mornings, the girls would head off to school after putting on whatever underwear they found lying about without bothering to ask whose it was. I knew from the haggling I heard on a daily basis when no clean ones were available, Akane and Asagi were happy to go out wearing the cotton bloomers once used by my mother-in-law, who had lived with us till she died aged eighty-one last year.

My wife, however, had started to put on a little makeup, as if the notion had suddenly come to her. I spotted her busily rubbing the middle of her face with a bit of gauze dipped in toner. She was obviously trying to do something about the grayish tip of her nose. Taking Akane's advice, Asagi had begun wearing a bra from time to time. She had never worn one before Mr. Mikami had started visiting us. Akane, Asagi and I also left magazines and newspapers in the toilet far less frequently.

Castro was the one who had changed most dramatically since Mikami had started coming. I don't know if it was the result of synthetic turf and a cicada diet, but his bumblefoot had gone and his appetite was back, and he had gained so much weight that Akane proposed making him into Peking Duck and having him for dinner. The quinine hydrochloride that Mr. Mikami had put into the water had cured the goldfish's White Spot and he now swam with his dorsal fin in its proper upright position instead of floating on his side.

At the same time as the animals were changing, the air plants were undergoing surprising changes too. They had once

been dry and covered with dust but now they stretched out their stalks—or were they leaves?—aggressively as if trying to catch some midair prey. Their green had a shine to it, and if you focused on them, you got the feeling the plants were moving their tentacles about.

Mikami even began to drop in when I wasn't there. Since the women of the house saw more of him, it was only natural for them to know more about him than I did.

They knew he had been a vet in Tokyo; that he was divorced and had voluntarily paid a hefty sum to his wife without her asking; that he was still fond of his wife; that he didn't have any children; that he now worked for some plumbing fixtures–related business in Yokohama; that he liked sweet rice biscuits. "And I just know he'll never invite us to come over and visit his apartment near the little park," added Asagi rather sulkily.

I wasn't prepared to believe all this, because it included some tidbits my wife had picked up from other housewives in the neighborhood. Anyway, finding out about him didn't make his pale, tenuous outline any thicker or more vivid. It wasn't just his outline, either. I had a niggling sense that his body had no substance to it. When he'd been up on the roof, the wind sometimes seemed to be blowing right through his thin, flat chest. I quickly dismissed the thought, but looking at him up there, I couldn't help feeling that he was like some imaginary number that turns into a negative value when you square it. I dropped the idea after asking myself if in that case the rest of us were all real numbers, which I wasn't entirely confident about.

After that, Mr. Mikami paid one or two whirlwind visits to the house a week, when he would wash the duck, change the water in the fishbowl and take care of the air plants. There was no sign

of Nekos the cat. Meanwhile, though I was convinced our house had not changed intrinsically, careful scrutiny would probably have shown that the tiny "non-dirty" area—what might be called the house's hygienic zone—was gradually expanding.

One day, Mikami turned up with some sandpaper and a bottle of thinner. He asked if it would it be okay for him to clean the graffiti off the front of the house. I felt a bit uncomfortable but, unable to come up with a specific reason to say no, I just mumbled something about whether it was really all right to have someone else do such a big job for us.

The thinner soon dissolved the thick paint of the lurid red RUBBISH, and it trickled down the wall like pink tears. But the paint had penetrated the cement slabs to the point where the shape of the seven letters remained visible even when the bright color had gone. Mikami and I sandpapered it for all we were worth, but it felt as though the stuff had permeated to the core of the house and would never fade away.

"This is hopeless. It's like rock candy," said Mikami with a pained smile. I didn't tell him, but I had come to see the message on the wall as a mark of shame.

Still, the RUBBISH had lost its previous neon brightness and if you screwed up your eyes all you could see was something like faint red capillaries. Look up, and there it was: a faint but indelible stigma.

6.

When I saw what Mikami had brought with him the next time he came around, I thought, Ah-ha, now he's really getting serious.

He stood in the hall looking thoroughly happy and holding a couple of T-shaped objects that looked like oversized windshield

wipers with handles, together with some rubber-grip cotton gloves and rubber gloves.

"These T-shaped things are called squeegees. They're for cleaning windows."

Rather unnecessarily, he asked "You don't mind my cleaning them, do you?" then got to work.

None of the windows had been done for about three years. The glass in them was supposed to be transparent but it looked like frosted glass; the kitchen windows overlooking the street were so filthy you couldn't see a thing through them.

My wife, Akane and Asagi initially reacted with wide-eyed amazement to the technical vocabulary he used in association with the verb "clean," but they had so much trust in him that once he'd given them a run-through of what he wanted done the girls got straight down to work without any time to brood about things.

"Glass cleaner is good for making windows shine because of the silicon oil in it, but once you've put it on you can't clean the windows with water, meaning they'll get dirty again surprisingly fast. So what we're going to do is wash the windows with plain water first, then squirt on a mixture of hot water and detergent with a vaporizer, before wiping the whole lot off with a squeegee."

Mikami didn't tell us that using glass cleaner from the outset was impossible because our windows were so disgustingly grubby. He also seemed to be taking care to avoid using words like "tidying up" too much.

I was put in charge of blinds. I could only marvel at Mr. Mikami's technique. He told me to put on a pair of pink rubber gloves, then pull the cotton gloves on over them.

"This way the detergent won't harm your hands. You let the

blind down, soak one of your gloved hands in the hot water and detergent and the other in the plain hot water, then sweep them across each of the blinds from left to right to clean them. It's a very effective method."

Leaving us to get on with our tasks, he brought the vacuum cleaner over and busied himself with cleaning the gunk-clogged flyscreens. He didn't just give them a casual once-over, but placed them on sheets of newspaper before sucking up all the muck and dust; when that was done, he pressed a sponge to either side of the screen and wiped, moving them in unison.

Mikami had already finished with the screens while we were still getting to grips with the unfamiliar techniques for cleaning the windows and blinds. No sooner was he done than he headed for the kitchen extractor fan, which, rather amazingly, could still rotate despite being coated in a layer of grease several centimeters thick.

"Have you got any soak-and-leave Magiclean?" he asked my wife as she was doing the kitchen windows. "No? Then how about some ammonia? None of that, either? Okay then, I'll be right back."

Mr. Mikami sped off, returning a few minutes later with what looked like a packet of powerful detergent. I could hear my wife and him talking.

"Could I use the sink? It's full, so I'd better just wash these things first."

The sink was such a towering heap of pots and pans and plates and vegetable peelings it was hard to believe there was any sort of cavity under it all. After a pause, my wife said loudly, "Oh, but I'm so ashamed."

What kind of voice was that? I had never heard her speak that way before. The hard crust of my heart cracked and split

at the sound. No doubt about it, my wife was sincerely embarrassed. The shame she spoke of seemed to burst out of her mouth from somewhere deep inside her.

"I want to soak the extractor fan blades in Magiclean in the sink before washing them. Honestly, it's all right. I'll do it. I'll stack them over here . . ."

Not wanting to make a meal out of her "Oh, but I'm so ashamed," which he must have sensed was the first such confession she'd ever made in her life, Mikami was deliberately casual. His mild voice was followed by the gentle clattering of crockery, the sound of water, him whistling, the girls laughing and a contribution from the duck. Every thing was going fine.

What the heck was I doing? I was startled all over again when I looked down at my hands swollen to gorilla-like proportions by wearing the cotton gloves on top of the rubber ones. What the heck was I doing? My hands inside the rubber gloves were clammy with sweat.

Was this really our house?

The windows had been rubbed so clean that mosquitoes and flies would have trouble getting a footing on them. Even through the flyscreens I could make out the individual leaves on the cherry tree that hung over the fence. Thanks to my handiwork the beige blinds were as good as new. The extractor fan in the kitchen was gray and stain-free for the first time I could remember. I gazed at the freshly washed blades thinking, Ah, I'd forgotten it was such a corkscrewy shape. And how many months was it since I'd last seen the stainless steel of the sink uncluttered and exposed like that? The tar-colored burn marks had vanished from the gas range. Mr. Mikami had found a wire brush and a gimlet in the storage shed and he'd unclogged the

gas holes in the burners and even polished the gas rings and the extractor hood. He probably knew more about what was in the shed than I did.

A brown bag of Canet dry cat food and empty cans of Jolly Pilchard cat food, polystyrene containers with scraps of shiso leaf sticking to them, transparent plastic sachets of Murasaki additive-free soy sauce—this together with various other things were still scattered around the kitchen floor, while loads of stuff sprawled over the living room floor and table. I had a sense that all of this would come within the ambit of Mr. Mikami's extraordinary powers at some point. I imagined the scene: him wrinkling his pale forehead, puckering his thin lips and breathing out with a blast of air that drove back in a cowering mass all the crap that had been hogging the space, as the four of us surged forward into the sudden emptiness to do our sweeping and polishing.

After Mr. Mikami had left, my wife, Akane, Asagi and I looked at one another with shy, halfhearted grins on our faces. We felt like people who had never met before and had been left alone together in a room by the host who set up the meeting. The girls' faces—I don't think it was my imagination—glowed. The sheen on my wife's face was verging on the indecent. The number of blackheads at the end of her nose seemed to have shrunk dramatically.

Mikami made the scales fall from our eyes that day, and my wife was the one who took his lesson most to heart. As I stared at the tip of her reconditioned nose, I was dismayed at how quickly her looks had changed.

I tried opening the window. It slid open with a newfound ease. The sound of someone practicing the first eight bars of *Innocence* nearby strayed into the room. Speeding up, slowing down.

. . .

That night the roar of the motorbike gang somewhere close by woke me again. I strained to hear. Most of them had driven off. Five or six of them, I estimated, were parked in front of our house gunning their engines. I heard the duck quacking. He was waddling frantically around his enclosure. There was a cackle of laughter. Then what sounded like the death rattle of a can being crushed—a horrible sound that made me want to rush down and beat them all to death. I pictured the face of a fly with a helmet on. A thud as a heavy object fell to the ground by the wall came next. I tensed. Should I go out? Should I confront them? Get dressed and go out with some sort of stick if I could find one? . . . No, we hadn't got one. I wavered as long as I could to make sure they had time to drive off . . . They drove off. In my relief, I finally let out the air in my stomach.

I waited some more. I listened closely to make sure that the roar had gone into the distance, dwindled to a point in the faraway darkness and disappeared completely. Then I went downstairs and opened the front door. The gate was ajar. I shuffled into my sandals and went out to close it. Castro was crouching there in the darkness. He quacked at me twice and I went back upstairs.

7.

Raindrops rolled like mercury down the well-polished windows.

I was holding an umbrella over Mr. Mikami and Asagi, who were squatting in the duck's enclosure. The back of Asagi's rain-soaked T-shirt jerked up and down. She was blubbering like a baby as she held the duck with both hands to keep him still. Her red-framed glasses were wet with rain and tears, and something red was reflected in the bobbing lenses. Mikami's fingers were

patiently wiping Castro's feathers one by one with a cloth that had been dipped in thinner. The cloth had turned bright red. Ditto Mikami's fingers and Asagi's chest.

Aside from part of his face, Castro had been sprayed bright red all over and looked as if he'd been dipped in blood. The paint had made his wings go rigid, and he had been lying tipped over on his side on the synthetic grass, having lost the ability to balance himself. With his body all crimson and his eyes glued open, he had patiently waited for someone to come and find him. He was exhausted. Some of the red paint had congealed into lumps that sank to the bottom of the pool.

Castro looked totally different: transformed into a painted and grotesquely thin toy bird. Mr. Mikami was taking his time wiping the stuff off the big feathers slowly and carefully, just as I had done with the blinds the day before. He cleaned them silently one by one, his thin lips clamped together, his expression that of someone who'd made up his mind about something. The gray-blue of his irises was darker and bleaker than usual.

"If this had been winter, he could easily have died of cold. There's nothing much we can do about his down. Just wait for it to grow back . . ."

He kept his emotion in check and spoke like a doctor comforting the family of a patient. Uh-huh, uh-huh, nodded Asagi, still crying.

"He won't have the energy to eat, either. You'll have to force his bill open to feed him. You'll need to add more water to his food and pour it down his throat with a spoon."

Uh-huh, uh-huh, nodded Asagi, stroking the one part of Castro's head where the down was still white and fluffy. The eyes framed inside gray-blue rings looked vacantly up at her glasses. They were like the glass beads used on stuffed animals.

Mr. Mikami had discovered something was wrong while walking past the house early that morning. He hadn't shouted or burst into the house, he just stood there in the doorway, his face very pale, as I stared, until he finally managed to bring out the words, "They got Castro."

"I should've gone out and confronted them last night. I should've sent them packing," I said, without going into why I hadn't and couldn't. Mikami's head drooped forward and his scrawny neck wagged from side to side. His lips appeared to be forming a phrase, but he spoke too softly for me to hear properly. "Monstrous. Monstrous"—I think that's what he was saying.

The duck wasn't the only thing they'd done. They had re-sprayed the word RUBBISH on top of the graffiti we had cleaned off. And this time they had thrown a full bag of rubbish against the wall directly below. They must have brought it over from the garbage collection point under the cherry tree. The black plastic bag lay open on its side, and batteries, empty cans of energy drinks and soda, plus what looked like a man's enamel shoe for ballroom dancing, had toppled out. Tangled up with all this was a welter of brown tape like wet seaweed that had spilled out of a broken cassette.

The sound of their screaky voices came back to me in the rain. I recalled the fly-like faces and the wire-strapped teeth from which those sounds had emerged. Maybe these people had overreacted to our cleanup of the day before and decided to take their attack on our house to the next level. I was scared, and my breathing felt constricted, as though my stomach had climbed its way up to the back of my throat.

"They're not local. The gangs from here'd never do anything so mean."

Akane, who was in her school uniform, had come out to have a look at the graffiti. She was convinced that it wasn't the work of anyone in the neighborhood.

"Let's get revenge. Spray the bastards' faces black," proposed Asagi to no one in particular as the tears ran down her cheeks.

"When winter comes and it gets colder, they'll all stop coming, so let's not do anything silly," said my wife, trying to be sensible.

I backed her up. "She's right, you know, at some point they'll just stop coming."

In a decisive tone of voice, Mikami announced that he would clean off the graffiti after getting back from work that afternoon, then left, heading toward the main road. But if we cleaned it off again, mightn't they get really crazy? Hadn't this whole thing happened in the first place because we'd followed his example? Gazing at his frail back receding into the distance, I started hunting, almost at random, for something to blame, before quickly thinking better of it.

Mikami had dealt with the writing on the wall before I made it back home, though predictably the seven letters were still visible, like a faint scar. There was no roar of motorbikes that night. Nor on the next day, nor the one after that.

Every day Mikami and Asagi slowly cleaned more of the paint off the duck with thinner. That done, they used a mortar to crush his food pellets to a powder, added water and stirred the mixture until it was smooth, then spooned it into Castro's bill.

Mr. Mikami spoke to Asagi in a quiet voice as they went on with this painstaking task. "In the West there used to be a legend that a duck pond suddenly turning blood red was a sign that somewhere battle had been joined."

I suppose he might have been one of those people who get angry quietly. As I stood there listening to them talking, I felt that I'd discovered something about his character. Wiping the individual feathers, his fingers moved as smoothly as if he were stropping a razor.

"I want revenge. I'd like to beat them up! Spray them with black paint! Make them feel just how much poor Castro suffered. They turned our duck red, fine, then I'll turn them black. This is war," Akagi raved.

I was curious to see how Mikami would respond, but he just changed the subject.

"Even after Castro gets a bit better and wants to start swimming again, we need to keep the pool empty for a while. It's a funny thing, but even naturally good swimmers like ducks can drown. If the fat glands don't produce enough grease to coat the feathers then ducks stop being waterproof and sink. So we need to stop Castro from swimming till all his feathers are back to normal and he can take care of them himself . . ."

While he was explaining this in his soft voice, several sparrows flew down, picked up some red feathers off the synthetic turf and concrete floor and flew off again. They must have been building a nest. A red nest. The bits of red sailed off into the blue background of the sky. As I followed their progress, I muttered: "Take it all. All of it. Take it all away."

It was a Saturday lunchtime in mid-October. The duck, who had spent a long time curled into a ball, had now perked up a bit and was able to feed himself. Nekos the cat had not come back yet. Mr. Mikami was eating with us. We had invited him often before, but this was the first time he had accepted.

My wife had made boiled octopus spaghetti with a green

salad. The De Cecco pasta was perfectly al dente and the black olives, garlic and parsley packed a punch, making it more or less good enough to serve to a guest. My wife had put her heart and soul into it. I also knew that this morning she had been doing a *gommage* to clean up the pores on her nose.

It was interesting to watch. As our guest applied himself to the dish, his prim, pale face made the sliced black olives, the grated parmesan cheese, the red chilies and the half-buried scraps of boiled octopus—even the spaghetti itself—look somehow silly, frivolous. He had the sort of face that remained imposing when staring straight ahead and munching its way through undercooked No. 11 De Cecco 1.6mm diameter spaghetti.

Mikami was a quiet and tidy eater, but he left seven circular octopus slices uneaten in a neat line on the rim of his plate like a collection of severed fingertips.

"I'm terribly sorry, but octopus isn't really my thing," he admitted mournfully. My wife stiffened, then apologized profusely, promising never to make the same blunder again.

Nonetheless, he said some nice things about the food, and after Asagi ate up his leftovers everyone relaxed, though a slight mishap did occur after the meal. Offering to help with the washing-up, Mikami ignored my wife's energetic protests and made his way into the kitchen, a room he was already familiar with. Not content with his skillful washing-up job, he also opened the refrigerator door to put away the unused octopus on the chopping board. My wife shrieked as though someone had discovered a dead body she'd been hiding, but it was already too late. A passing ship had finally come to the rescue of Géricault's raft. I painted a mental picture of the raft—heaped with the naked, the sick and the dead and stinking to high heaven—being dragged onto dry land.

"Could I tidy this up?"

Even as he asked the question, his pale fingers were already in motion.

He pulled out a lump of meat. Still on the bone, it looked like an amputated human leg. Things that resembled melting eyeballs, congealed blood, cold intestines and flayed skin were placed neatly on the draining board. As the amorphous outlines of this parade of dead and long-forgotten objects were exposed, Mikami's white fingers were the only thing with any clarity as they decided with a pathologist's detachment what had any function and what not.

But farther back in the refrigerator, the process lost all meaning as he began to find things that had degenerated into shapes that were defunct, disembodied, void. Mummified cat shit. A miniature snow-capped mountain. The hair of a dead old woman . . . Things that at one time had gone under the more ordinary names of rootstock, cheese, seaweed.

As though lured into it by Mikami's fingers, the red, blotchy hands of Akane and my wife joined in the work of sorting. Asagi and I held a gray garbage bag open to receive the trash.

It was then that my eye noticed a puzzling phrase with no subject printed on the bag: "Made with low density polyethylene. Biodegrades naturally through the activity of microorganisms when thrown away." What did it mean? That the garbage bag was so painfully garbage-conscious that it was promising never to turn into garbage itself? Or ambiguously, was it telling us that the rubbish inside the bag would biodegrade naturally due to microorganic activity? How convenient that would be! What could be better than rubbish that automatically decomposed when you stuck it in the bag! This was how I wanted to interpret it anyway. Wouldn't it be great if trash that couldn't be incinerated melted into the sort of goo you get in horror films

before being swallowed up in the earth . . . Wouldn't it be handy if I could just stuff those tinny-voiced bikers into this bag, helmets and all, and turn them into goo? . . .

"Have you got any ethanol? What about Cleanboy? Liquid cleanser?"

Mikami's brisk voice snapped me out of my reverie.

The refrigerator had been emptied and it was gleaming white inside. Only such meat and vegetables as had passed the quality test were wrapped up and snugly stowed away. Throughout my body I felt a cleanliness and a coldness, as if my innards had been removed and the wind was blowing right through me.

Asagi was cramming the stuff lying around the living room into garbage bags. Akane was cleaning the murky door of the microwave. As though manipulated by Mikami's hands, we bent down to pick things up, stood on tiptoe to clean things, knelt down to fold things up. Our underused joints made sounds like twigs snapping.

After a while everything began to give off a definite glow. With Mr. Mikami at its radiant center, we stood and stared at what looked like someone else's place. The only slight blot on the scene was the Burgmüller piano étude, which barged in through an open window and slid over the polished wooden floor to the white door of the refrigerator.

"We've done this much, so we might as well deal with the walls and the roof. No need for a professional decorator, we can do it ourselves. After all, where there's a will . . ."

We agreed to Mikami's proposal with an extraordinary lack of hesitation. My wife and daughters seemed strangely happy. Her nose and forehead glistening with sweat, my wife was particularly enthusiastic, and she'd blurted out "—there's a way"

after Mikami's "where there's a will." She looked as though she had a geothermal spring bubbling up somewhere inside her.

Before dropping off to sleep that night I heard the roar of the motorbikes for the first time in ages. They went past our house, one bike at a time, on their way to their rendezvous in the park. Wave after wave of piston-driven anxiety surged through my chest. I piled on some clothes and went downstairs. The front door was open. Asagi stood in the porch clutching the duck to her chest. He still had the odd blotch of paint on his body. She was scowling at the street.

"I want to make them suffer!"

There was a rumble as another bike came toward us from the main road. "Listen, Daddy's going to go and have a word with them, so I want you to stay indoors." As my mouth said the words, my hands pushed Asagi, duck and all, into the house. I shut the door and turned around. There was a burst of light in my eyes as a black shape roared by. My legs started walking reluctantly. I realized I was wearing sandals. I was thinking, *Barefoot's best for running away.* But doing nothing wasn't an option. I'd go and confront them. No, I'd intend to confront them but flunk out. That would be good enough. It was doing nothing that was unacceptable.

I approached the park scuttling along the curb in a half-crouch under the cherry trees. No rumbling behind me. The hard, cold bark of a tree brushed against my cheek. The night air smelled oily. Was it the cherry tree bark or the exhaust fumes from the bikes?

Churning up the darkness, a throbbing noise lay coiled in wait in the park I was heading for. The whole gang was there. I suppose everyone in the houses close by was busy pretending to be asleep. The people around here were good at pretending to be

asleep or to not care. I felt something squish under my sandal. A brittle scrunching sound traveled through me from the sole of my foot up to my ears. A cicada? Had I killed one lying there in a state of suspended animation?

On the other side of the low camellia hedge that encircled the park, several gleaming black bulbous shapes were moving to and fro or melting in and out of the shadow of the hedge. They reminded me of the insects fluttering around the streetlight at the park entrance. There were fly faces with protruding metal braces attached to the bottom of the shiny black things.

Still in a half-crouch, I crossed from the cherry trees to the hedge and hid there while I paused for breath. The din of engines merged to make the fleshy leaves of the camellia vibrate. I heard the shriek of metal on metal coming again and again through the darkness. That's the sound they make, I thought. Insects with those voices are never going to listen to a telling-off from a person like me! Even a halfhearted reprimand would send them into a frenzy, make them screech even more stridently.

Pulling myself together, I peered into the park through the branches of the camellia. Several praying-mantis-shaped machines were parked inside. But the high-pitched squeaking was not coming from there. The swing and the seesaw were moving. It was coming from them. In the middle of the night, the insects were playing on the swing, and a total of four of them—two at each end—were sitting on the seesaw and fooling around. Several of their pals were clambering on the jungle gym, their hard helmets bumping noisily against the metal tubes; others were going down the slide with their long black legs twisting or jerking about. As I watched them playing in the park at night, I felt as if I was looking into an insectarium.

And how could I possibly tell them to stop? The minute

I opened my mouth, they'd all stop horsing around, turn and come scuttling toward me with their hard black heads. I couldn't bear the thought. They'd chew me up with their metal teeth. What could I do except slope off home?

As I wavered like this, the tall one who appeared to be their leader strode over from the swings to a motorbike parked with its taillight toward me just on the other side of the hedge. His visor was down so I couldn't see his face. Turning his back to me, he got on his bike and fired it up, then looked down to check the magneto and the carburetor. I was crouching in a cloud of exhaust. Next he removed his helmet. Having expected to see a fly's head pop out, the thing sticking out of his jacket gave me a shock. It was the bare nape of a neck with close-cropped hair above. A blur of lily-whiteness, it looked too weak to bear the weight of so large a helmet.

Squatting there, I felt relief dissolving the tension in my joints. The neck was so thin and pale I could almost have reached out and touched it . . .

Eventually the rest of them swung their legs over their bikes and drove out of the park and along the street in a cavalcade. The one with the white neck was in front. They didn't appear to stop at our house. With the insects gone, the little nighttime park reverted to the lonely silence of a deserted hive; only the twin chains of the swing moved gently to and fro.

8.

Early in the afternoon on Sunday one week later, our mouths were busy working on a salad of mâche lettuce and endives with fried bacon and thin slices of garlic French bread. The weather was nice. The duck was quacking away merrily. His feathers had

mostly grown back so it wouldn't be long before he'd be able to swim again.

The bikers hadn't been back since I had gone and spied on them in the park.

"Guess they got fed up with this bit of town and went off somewhere else," said Akane.

"Those sort of people tend to do their thing in summer," said my wife. "It's the end of autumn, so I'm not surprised they've gone."

I hope that's true, I thought to myself, but after my glimpse of that pale neck I was about a third less worried than before. And since the duck had started to recover, Asagi had all but stopped talking about getting revenge.

The scabrous, tongue-like leaves of the air plants on the windowsill writhed in space. The light, crisp sound of endives and bread being crunched came from four mouths. Every now and then piano music was audible through the well-polished window. The soundtrack of the music show we were watching on TV lay on top of the other noises like so much salad dressing.

We had become really serious about cleaning. This morning we had all set about the housework as a matter of course.

"When the place gets tidier, I feel calm and happy inside."

My wife had blushed after making this remark at the time, a little amazed by what she herself had said. I had a feeling that our domestic principle of "undiminishing inventory" was starting to break down. The house had a set allocation of stuff which, though it might increase, could never decrease in quantity. You could delude yourself that you had tidied up, but the stuff would just be filling up a different space in another part of the house. This conviction had set hard inside me like tooth plaque, but the

various things that had occurred since Mr. Mikami had started visiting us were gradually eroding it.

But how did I feel emotionally? If this was what people called "feeling good," then it seemed a little bit soulless.

The TV screen looked brighter after a polishing with a Duskin cloth. The music show was followed by the news. Akane used the remote control to turn the volume down, so that the presenter's mouth continued to move, but soundlessly. Everyone else was focusing on their salad. There was some bald foreigner I'd never seen before on the TV. The bacon and mâche lettuce in my mouth had been chewed to the point that they'd turned into a bittersweet paste. The yellowy-green of the endives was reflected in Asagi's red-framed glasses.

We had a final discussion about getting the house painted. My wife had taken the step of calling her uncle, the landlord, to sound him out, and he had basically said yes. None of the family was against the idea. Our anxiety hadn't gone completely, but the fact that the bikers had stopped coming was encouraging. Maybe that was the end of the graffiti story.

"I won't let them get away with it if they paint Castro again," Asagi declared out of the blue, but there was a smile in her eyes.

"Let's make the place beautiful inside and out . . ." My wife almost sang the words. I could hear the piano, Asagi munching on her bread, and the quacking of the duck, one sound on top of another. Using the tip of my tongue to probe for a thin slice of garlic stuck between the teeth toward the back of my mouth, I tried to draw myself a mental picture of an all-white, two-story house.

That evening we had arranged to take the train with Mr. Mikami to Tokyu Hands, the big D.I.Y. store. Mikami had drawn up a

shopping list for us. One look at it was enough to bring a vision of our drab gray box glowing white against a blue sky into sharper focus. Exterior paint (white, water-based); roof paint (green, oil-based); spray paint (white); paint thinner; rollers; wall brushes; angled brush; masonry brush; sandpaper; paint scrapers; masking tape; paint trays . . .

Initially I had proposed doing the walls in an ivory color, but an uncharacteristically insistent Mr. Mikami argued for white on the grounds that White Day was a lucky day, as were days marked with a white stone; besides, white also had associations of purity and innocence for everyone everywhere. As I listened to his explanation, the phrase to be "white with fear" elbowed its way into my mind, but since it was hardly encouraging, I said nothing about it and crossed the thought out. Okay, I nodded. White it's got to be. White.

Since Mikami knew exactly where the various items were in the store, the shopping was over a great deal faster than I had expected. The five of us divided the bags up between us and piled into Denny's, where we had dinner imagining the smell of fresh paint and discussing how different the house would look.

We decided to do the painting on the Saturday afternoon and Sunday of the coming weekend. In a little girly voice, Asagi asked Mr. Mikami whether it would be okay for her to do a little bit of painting work before Saturday.

"Anyone who has time in the week can clean the dirt and stains off the walls with sandpaper or a brush," he replied as gently as he could. "The roof is dangerous, so I'll take care of that with a scraper and wire brush on Saturday. You can't do a good job of painting unless you're meticulous about the preparation. Neglect that and you'll get patchiness and dirt showing through. You may think white's an easy color, but in fact it's the most difficult."

• • •

There was no noise of motorbikes that night. As I lay waiting for sleep to come, I wondered if they might be planning to switch off their engines as they approached. I hoped not. I dropped off thinking it would be nice if they'd just evaporate, like gasoline.

The next morning Asagi discovered something on one of the air plants hanging from the windowsill. There was a single, white, pearl-like ball wedged in the tillandsia's foliage, which spread like the tentacles of a headless, bodiless octopus. Asagi prodded it with the tip of one finger. A shiny granule, its outer skin was stretched to bursting point, perhaps because it was full of white gunk. It looked like a single drop of the coarse leaves' sweat.

"Look!" she said. "It's not something somebody stuck in there as a joke. See, it doesn't move. It's a bud, a white bud. This is a miracle."

White. As Mr. Mikami had said, surely a good omen; an auspicious sign telling us that our house was about to be born again in purest white. Like a bagworm inside its bag, we were changing. We wanted our bag to look good. At first it had been dreary work, but the more we did it, the better it felt. We were no longer worried about being overloaded. The unidentifiable objects on the raft of the *Medusa* had been disposed of.

The secret was to throw things out. As a formula, it sounds almost disappointingly simple, but ruthlessly chucking out anything that's not immediately useful is actually more of a challenge than it sounds. Your first impulse may be to think it's easy, but buying something very expensive on credit is indecently straightforward compared to deciding to throw something away.

Mr. Mikami told us this without irony and with the hint of a smile on his lips. "You can't live your life unless you discard things." He paused a beat. "Look, if 'ruthlessly' sounds a bit over the top, let's say 'untiringly.' As things untiringly accumulate, he explained, you have to weed them out just as untiringly. And it's true; if this man hadn't come into our lives, we might never have seen this for ourselves, and slowly succumbed under a mountain of rubbish.

Mondays, Wednesdays, Fridays and the first and third Tuesdays of the month had previously just been days like any other, though very occasionally one of the four of us would remember that they did have something to do with putting out the trash. Our tendency was to remember either on the wrong day or just as the dark blue garbage truck was moving off, its tailgate callously closed. Now, we had all committed it to memory like a hymn you can sing without needing to look at the hymnbook: Monday, Wednesday and Friday were combustible garbage days; first and third Tuesdays were noncombustible garbage and bulky waste. For us, the timetable was like a series of holy days whose advent was to be treated with proper solemnity.

Like bulky waste themselves, the bikers had disappeared, or were in the process of doing so. The duck had recovered and was in the process of growing new feathers.

The painting of the house was the celebratory summation of all this and the white bud on the air plant was a pre-celebration. The Burgmüller étude had as much flow and verve as if Christophe Eschenbach were at the keyboard. The eighth notes of *Innocence* flowed in a smooth *legato* like a glinting stream. I pictured the music smiling to itself as it glided down the white walls of our two-story house.

9.

Since the duck's feathers had started growing back, almost no trace of the red paint remained. The bud on the air plant was gradually getting bigger. We pushed on steadily with the preparations for painting the house.

On the Tuesday designated for bulky and noncombustible garbage, my wife threw out a broken kerosene fan heater we hadn't used for two years and a color TV that had been in the storage shed for a decade. I threw away an old leather suitcase with a broken handle, a cassette recorder that didn't work, and a dial phone as black and heavy as a rock which was my first purchase after we got married. Since beginning to jettison things, we had freed up five times as much space in the house as before, but we still felt there was more to be done before the day of the house-painting came around.

The fan heater and cassette recorder were both mendable, and the TV still worked, though the picture was a bit grainy. We discussed what we should do, but no one could come up with an argument that trumped throwing them away. Ever since Mr. Mikami's arrival on the scene, we were united in recognition of the fact that forgetting about things or holding on to them for too long was out and away the No. 1 cause of untidiness.

What we realized by dint of actually doing it was that when the moment came to get rid of something, our faces didn't say "Ah, that's a relief," but wore the stern expression of seekers-after-the-truth who have cast aside pity for moral reasons. This was particularly true of my wife.

When she threw out the fan heater, which had cost quite a lot of money, she stood at the collection point by the cherry tree and gazed for a while with a wistful look at the black metal

box which was by no means completely dead and useless. Then, abruptly, looking solemn and serene (I'm not exaggerating) and muttering something under her breath, she turned on her heel. "You're giving your life for a worthy cause," her face seemed to be saying to the broken heater.

Maybe I looked like that myself when I chucked out the old-fashioned phone I'd had for nearly twenty years. The thing had been so stiff it hurt your index finger whenever you dialed a number on it. The cord was wrapped in some thick black material. The receiver was big and heavy, while the round holes the sound came out of were arranged in nice honest rows that had a certain dignity. This was not the sort of phone to suffer silly light-weight conversations gladly. It still maintained a solidity and a weight in my eyes even when placed there under the cherry tree. As I walked away, the cracked voices from phone conversations of twenty years ago all cried: "Don't throw it away! Don't throw it away!" Behind my back, the niggling sounds went on coming from the small black holes.

On Wednesday, the day for combustible garbage, Akane tied more than thirty volumes of *The Glass Mask*, a comic she'd had since junior high school, into a bundle, and after Asagi had done the same for about forty volumes of *Doraemon*, they let the whole lot go. I myself got rid of over thirty paperback thrillers and historical novels. We could easily have put the things we threw out that Tuesday and Wednesday into the next local flea market, but we were all conscious that "We can always put it in the flea market" had been a catchphrase we'd used as a pretext for holding on to junk for years and years. Now that we were busy eliminating things, any mention of the words "flea market" was taboo.

Following on from where she'd left off on Monday my wife was getting rid of old clothes. On Wednesday, in addition to

some large articles of clothing, she crammed lots of smaller, ragged items into a couple of doubled-up plastic bags from the supermarket whose necks she tied scrupulously shut. She performed the task with her back to me, so I didn't ask her what was being condemned, though I had a hunch it was her ten-year-old panties, my underpants and her dead mother's underwear.

As though the more we threw out, the more merit we would earn, we were in competition with one another to get rid of things, to clear space, and to clean that space in readiness for the day of the allover paint job. The bikers did not appear once during that week.

Saturday came. The air plant, as if working to order, had put out its single flower. The bright blue sky looked as though it had been completely coated in cellophane the color of dayflowers. That morning the four of us washed our faces and brushed our teeth so scrupulously that the smell of toothpaste pervaded the house. We all looked a little prim and proper but with the hint of a smile on our lips. We felt that we were going to be baptized today.

Akane, Asagi and I decided to leave school early in order to be back by one. We had reconfirmed the plan on our way out of the house, and all three of us came home at the agreed time.

Asagi shampooed the duck and hosed down the synthetic grass to wash away any droppings. My wife, Akane and I cleaned the kitchen and living room—this despite the fact that my wife had already done all the cleaning once while we were at school! We just needed to fill in time. The rest of us changed into gym kit, while Asagi got into dungarees, and heading outside we arranged the painting things, a stepladder and an extendable ladder neatly beside one gray wall. Several cans of white paint stood lined up waiting for their lids to be opened.

Mr. Mikami came walking down the avenue of cherry trees just as the child next door was starting the Burgmüller piece. He wore a white coat that reached down to his knees. The music bounced off the snow-white cloth like drops of water.

"Wow . . . ," sighed my wife.

I suppose one could describe him as looking dignified but in an unpretentious way. Just as he'd been on the Saturday in mid-September when I first saw him, he was quiet, his footsteps making no sound. There was an authority about him now which I hadn't felt then. Was it the white coat? Rather than reminding me of his veterinarian past, it made me think of a doctor in the broadest sense, a doctor, say, of "human environmental hygiene"—if that isn't too weighty-sounding.

I'm not sure who first put out their hand, but one by one we all shook Mr. Mikami by the hand as we stood in a line under the wall to greet him. I was surprised at the spontaneous way it happened, but I was rather more surprised at how cold his hand was. The gray-blue in Mikami's eyes looked bluer than usual. His clear voice ricocheted off the gray wall.

"So, shall we get down to work?"

The first stage of the plan had been to scrub down the walls. Since we'd already got rid of even the grime and spiders' webs at the foot of them using assorted brushes, all they needed now was an inspection. We had also scrubbed and scrubbed at the graffiti, but like a faded bloodstain it was still up there.

Thinking we could now get going with the painting, Asagi stood ready, brush in hand. "The heads of the bolts holding the cement boards in place are rusty, and we need to sandpaper off the rust," Mikami told her. "The white paint will get very dirty if any rust gets mixed in with it. I'll do the high-up part of the wall . . ."

We were very thorough. Alongside Mr. Mikami, we focused so hard on getting the rust off the bolts we almost went cross-eyed. Now surely we could get down to the business of painting? But no, not yet.

"We need to cover any place we're not going to paint white with masking tape. Be especially careful with the window frames and the drainpipes. Cover the windows with newspaper. And put newspaper over the windowsills."

Mikami came over to me after delivering this advice. He looked radiantly happy. Rubbing his hands with their long, thin white fingers, he said, "You know, it's interesting. When the professionals do this kind of masking and covering, they say they're taking proper care.' Doctors say the same. And they think that a good job of painting," he continued, "all comes down to whether or not you take proper care." Then he went off to help a floundering Asagi take care of her bit.

It took a while, but finally the preparatory work was complete. Standing in front of the four of us, Mikami launched into an explanation of the next stage.

"From a purely technical point of view, it would be best to start with the roof. However, I've decided that we should start with the walls because I want us to share the enjoyment of painting them white and seeing them change color at the earliest stage possible."

His introductory remarks were certainly effective. As they clutched their rollers, wondering when they could finally get cracking, Asagi and my wife nodded so emphatically that I heard a distinct clicking sound. With us now firmly on his side, Mikami, looking serious, explained that in painting there was no room for shoddy work, and if we were going to end up with uneven, patchy color and dirt showing through it might be

better not to start at all. This was the message he gave us. We felt tense and anxious. As though he had sensed our anxiety, he continued: "You can't use the new brushes straight away. Too many bristles fall out and get into the paint. So I want you to massage the brushes, give them a good squeeze. Sandpapering the tips of the bristles is a good technique. It makes the loose bristles drop out."

Brushes dealt with, his preamble went on to cover the need to stir paint thoroughly and to work on difficult spots like corners or behind drainpipes with an angled brush. My guess is that Mikami knew that painting a drab wall white was a tricky business that was easy to botch and cleverly put a check on our eagerness so as to steer us toward success. I had been an art teacher for years but was hopeless at dealing with students who talked or fooled around in class; Mikami's handling of us amazed me.

"Right, let's do it. Let's paint our socks off."

The instant we heard him say this in a completely different and cheery tone of voice, we sprang into action like mechanical dolls whose springs had been wound up as far as they could go.

Any slight impatience I'd felt at Mikami's speech evaporated the minute I applied the first stroke of white to the gray wall with the roller. I'll remember this one beautiful stroke for the rest of my life, I thought. The white water-based paint had a sweet smell like brandy. We were intoxicated by its snowy scent.

Tentatively I painted a broad white line up the wall. My hand was timid and the line was faint. Putting a white stripe on the dreary expanse I'd got so used to seeing over the years felt like an act of desecration, and I was holding back. Soon, however, I found myself stimulated by the contrast I had created between the white and the drab background. The gray on

both sides, the gray above and the gray below had now become something I was anxious to get rid of. Power surged into my roller and I seriously applied myself to extending the white and shrinking the gray zone. I enjoyed the sensation of my right hand grasping the roller. I had the sense that Mikami could see how I was feeling.

"Draw a big sideways V, Asagi. That's right, V as in 'Victory.' Your first stroke should be a sideways V, and the second a vertical one. That's what produces the best results."

As he dispensed this advice, he was making careful use of an angled brush to paint the wall behind the masked drainpipe. He let us do the fun bits of the job, while doing all the dull and difficult stuff himself. The white zone had expanded so much that I almost didn't notice, but somewhere along the line Mikami had pulled on a pair of gloves every bit as white as the paint. In white coat and white gloves he applied white paint. The brush in his white-gloved hand stroked the wall behind the drainpipe nervously, repeatedly, as though disinfecting the walls of a house that had been polluted by some epidemic. I shuddered slightly, but Mikami's cheerful voice soon set things right.

"There's a spot of paint on your nose, Akane . . . And your mother shouldn't just splash the roller around in the tray like that. Try to coat it evenly and not let it drip."

Once he had finished the back of the drainpipes, he got to grips with the red stain left by the graffiti. Standing on the stepladder, he painted a series of sideways and vertical Vs over the vestiges of the word RUBBISH. RUBBISH finally disappeared. It was disappointingly simple. So simple, in fact, that I was sure I could still see the seven letters through the paint.

Where had they gone to? Wouldn't the red letters slowly seep their way out onto the white of the wall? Mightn't someone

come along and spray red all over this nice white background again?

"No one's going to spray anything here anymore . . . I hope," Mikami said, though no one had asked him about it.

The painted area and the smell of brandy spread rapidly outward. Since the wall facing the street was now almost entirely white, Mikami, in white coat and gloves, sometimes briefly disappeared into it altogether.

By the time the pale blue sky had turned to a deep indigo twilight, we had finished painting three surfaces: the wall facing the street, the wall facing the next-door house across the fence, and the wall with the front door. Progress was in line with Mikami's plan.

Sturdy against the indigo sky, the walls of the shimmering house gave off a faint, sweet smell. We stood in a line in the street to have a good look. Asagi, the bib of her dungarees and the lenses of her glasses speckled with white, had her arm around the shoulders of my wife, whose face was white all over. Akane, who had flecks of paint on her nose and forehead, was muttering to herself with her arms crossed. Maybe because she was tired, her tic had come back and she had her chin up and was rolling her eyes back in her head.

"So this is what chalk white looks like . . . Well, it's not going to look like the White House, but still . . ."

"I'm glad we chose white. It's the best, isn't it? Lovely. I thought it would be." My wife was talking to herself.

"Tomorrow. We'll finish it off tomorrow. We'll have the green of the roof as well as the white. It'll look even better," said Mikami. Then he took off his gloves, shook our hands and walked off along the avenue of cherry trees after turning down an invitation to dinner. We watched him go until his frail white back had melted into the twilight.

We all went to bed early that night as we were tired. I wondered if the bikers might show up, but they didn't.

10.

The sky was the color of a bellflower: a purplish blue like a jelly that had neither melted nor set, and banded with translucent streaks. The house, freshly painted, looked as though it had been drawn on the air with a paintbrush.

Standing side by side on the street, we gazed intently at the gleaming walls. They seemed a degree whiter than when we had looked at them the night before. Castro the duck stood near Asagi with no trace of red paint left on his body; his feathers were just as white as the walls.

We only needed to do the roof and the area on the storage-shed side to finish everything off. This morning we had cleaned the rooms behind those walls as carefully as if we'd licked every little bit of them with our tongues. Running the vacuum cleaner over a floor without a speck of dust, I felt that chilly sensation you get when you've really scrubbed yourself all over. What would happen once we put our brushes down? Would there be anything left for us to do?

Someone started practicing the piano. *Innocence* again. Come on. You're not making any progress. It had been like that when Akane was learning the piece: so hard not to get bogged down in the run of eighth notes. It was meant to be played in a smooth *legato*, but it came out in stops and starts like water from a faulty tap. It was clumsy, stiff, jumbled together.

Mr. Mikami arrived. Today he was in a green bomber jacket. A long white coat was clearly not the thing to wear on the roof where it would be hard to get a solid footing, while a green

jacket made sense for painting the roof green. One after another we reached out to shake his cold hand, which responded with a surprisingly powerful grip.

"This is our last day. We'll finish today."

Akane and I were assigned to paint the wall. The dangerous job of doing the roof went to Mr. Mikami, while my wife and Asagi were to take care of various odd jobs. Asagi got into a sulk, as she was desperate to help with the roof.

"Oh, all right then, you can . . . you can come up just once. I'll call you after I've finished scraping off the old flaky paint and everything's ready. I think it would be best if you could do the first coat."

Having placated Asagi with this offer, he turned to me and solemnly promised to be very careful.

With his tools clutched under his left arm, Mikami climbed up to the roof. Akane and I turned our attention to the sunless wall on the side of the house where the storage shed was. Mikami's jokey voice came down from the rooftop.

"Now don't forget—take proper care."

The wall had three windows and two drainpipes. Covering and masking were definitely the order of the day. We had, however, used up all our old newspapers earlier, so my wife brought out three papers from today and yesterday, and with a thick wodge of insert ads as well, we thought we could more or less manage.

Mikami didn't let the old paint he was removing blow off the roof, but took the trouble of picking the flakes up with a piece of sticky tape, which he rolled into a ball, then dropped— after a conscientious "Here it comes!"—down to my wife and Asagi, who were waiting below. Asagi ran around looking toward the roof through her red-rimmed glasses and trying to catch the

balls before they hit the ground. The duck ran after Asagi. The dry tread of Asagi's sneakers and the wet patter of Castro's feet went together. Cries of "Come on, throw it," "Good catch" and "That was close" echoed off the white wall into the blue sky.

What would happen if Mr. Mikami left us? . . . The thought came to me suddenly as I was papering over the window of my wife's room on the first floor. What would happen to us?

Even through the window it was clear that the room was unbelievably tidy, and its spotless dressing table and immaculate cushions on the tatami had been somehow transformed into the possessions of a woman I didn't know. If Mikami were to leave us, would we be able to get on with our lives? I wanted him to keep coming to the house for a while longer till being methodical and tidy had become second nature for us. I was worried. Perhaps when he'd said "This is our last day" as he shook our hands, he wasn't talking about decorating, but about visiting the house?

I could hear Mikami and Asagi.

"Good catch."

"No sweat."

The duck was quacking as he scuttled about.

I was busy taping the edges of the newspaper to the window frame, thinking *You have to take proper care*. Akane's fingers were pressing one side of the newspaper down. I could feel her warm breath on my cheek. She whispered in my ear. Her voice was as soft as down on my eardrum.

"Look at this. Isn't it horrible?"

"Huh? What do you mean?" I asked, cutting a length of Scotch tape.

"Oh my God! His head . . . it was chopped clean off!"

"What're you talking about?" I looked at Akane's up-tilted chin. The round tip of it was pointing more or less at the middle

of the window we were busy covering up. There was an article four columns wide.

Young Biker's Death.
Head Cut off by Wire Stretched Across Road.

What on earth was this? The wind made the words in the headline—death, wire, head, cut off—jump about. I couldn't make the connection between what was written and what had happened. Akane spoke quietly.

"Urgh! It wasn't far from here."

The paper we were using was the Saturday evening edition, and we'd been too busy with our work to read it. My eyes rapidly skimmed the article.

It had happened in a neighborhood that was four bus stops—or a single train station—away. Late on Friday night, a number of young bikers had ridden into a wire stretched between two trees. The young man at the front of the group had had his head sliced off and died on the spot, while two more had injuries that were expected to take two to three weeks to heal. That was what it said.

The words "bikers" and "gang" leaped out of the article at me. I looked for the word "rubbish" in vain. "Premeditated crime" I found. Could this have something to do with us?

I examined the picture of the dead youth. He looked strange without a helmet. It wasn't a fly's face. I don't know if the photo was out of focus or just badly printed, but it was blurred and hard to make out. When I screwed up my eyes, the young man appeared to have eyes as round as a dolphin's and a smile that cracked his narrow lips all the way up to his ears.

His neck was very thin. I made a furtive comparison with the bare, asparagus-like neck I'd caught a glimpse of from the

park hedge. I imagined a black line, invisible in the darkness, stretched at a ninety-degree angle to the white asparagus. "So you can slice off someone's head with a bit of wire, eh!" Akane's breath was hot on my ear. Her mouth quietly framed the same question I was asking myself. "Wonder if it's the same gang that used to come around here?"

"Oh, I doubt it," I replied. *Could well be*, was what my tone of voice implied.

Above us, Mr. Mikami noisily scraped off more of the dandruffy flakes with his metal scraper, collected them, and threw the balls of tape down to us. Asagi fielded them, while my wife put them into a plastic bag one by one.

"Here it comes."

"Here! Over here!"

"Nice catch."

I decided to have a look at the Sunday morning paper, which I had just wrapped around the drainpipe. While Akane was busy prizing the lid off a can of paint, I went to the drainpipe and slid the cylinder of paper around and around, searching for the article. Next to a story about a fire in some building in New York, I found a follow-up report on the killing.

Piano Wire Tipped as Cause of Death.
Young Biker's Death Ride.

As I read the headlines, I felt as if there was a bowstring inside me that had been pulled taut and was vibrating with a high-pitched hum. Hiding the article around the back of the drainpipe, I checked that Akane was still crouching there dipping the angled brush into the paint pot. Then I slid the article back to the front and went through it closely.

Originally, they'd thought the metal strand had been ordinary wire, but further investigation had revealed it to be piano wire from the upper register with a diameter of 0.775 millimeters. The young bikers apparently assembled on an empty tract of land in a residential area, then rode in a group out onto the main road. The piano wire had probably been put in place on one of the tree-lined residential streets just prior to their setting out. My hands again shuffled the article around behind the drainpipe.

I went into the storage shed for a look. It was neat and tidy and it didn't take me long to establish that it no longer contained any piano wire. The wire had been left by the piano tuner in the days when Akane was learning to play, and Mikami had used some of it to put the TV antenna back up when it had fallen over. He'd used a lot, so it was hardly surprising that there was none left now, but I couldn't help thinking there should have been a bit to spare. I'd feel reassured if there was. But even if a bit were left over, that wouldn't really clear everything up, would it?— and there not being any left in the first place couldn't really be called proof, either. The tripwire remained hidden in the darkness. I felt I was being drawn toward it.

Leaving Akane to get on with the painting, I went up to my room on the second floor. Looking up at the roof on my way into the house, I saw that Mikami had put on a pair of blue protective goggles and a round mask of white plastic over his nose and mouth. There was something nasty about the hundreds of anti-fog perforations, fine as the holes in a tea strainer, on either side of his eyes. The skin of his face was almost completely concealed, and it felt as though we had the Invisible Man crouching on our roof. He must have spotted me through the goggles, as he gave a sweeping wave of his right hand, black-leather-gloved and

clutching the silver scraper. From up there, the Invisible Man asked me a question in a muffled voice. It sounded like something coming from a faulty loudspeaker.

"Going—all—right?"

I swallowed and managed to stammer out a reply. I think my voice was dry and forced.

"Yep—seem—to—be—doing—okay."

I lay down to think in my room with its masked windows. As I shut my eyes, I pictured a street lined with cherry trees in the night. I tried telling myself I didn't have a shred of proof; that it was simply crazy to try and connect it with us like this. But it made no difference: a single, immensely strong black line, fine almost to the point of invisibility, was stretched across the darkness inside my head. Tight and unsagging between the two trees, the straight line of steel sliced the darkness into horizontal halves.

I could hear the sound of metal scraping against metal above me. Mikami was still working on the roof with his scraper. My head shrank back into my shoulders.

The neatly sliced-off head floated in the darkness. I had seen one like it in a photograph of an old painting once. It was the head of John the Baptist suspended in midair in Gustave Moreau's *L'Apparition*. But that head had long hair and a beard. It wasn't the head of a young man with a neck like soft white asparagus.

I wondered if the kid's head had briefly teetered on top of the piano wire like a single note. His head as a semibreve. The bike and its headless rider keeping on going as if nothing had happened. And after they'd gone past, the semibreve falling down and rolling along the ground.

I saw the tree trunk with the wire wound so tight it was biting into the bark . . . a cherry tree, I'm sure . . . and someone hiding in its shadow, watching quietly as the head floated on the darkness . . . I had a go at inserting Mikami's skinny body behind the trunk of the tree.

There was a series of sudden heavy thumps on the ceiling and I leaped to my feet. Mr. Mikami, begoggled, metal scraper in hand, was walking about on the roof. My head felt heavy. The noise was so loud I thought the roof was going to cave in. Mikami had turned into a giant.

"Lunchtime! Time for lunch everybody!"

That was my wife.

Asagi came to call me down. The plan was for us all to go out to eat. "Sorry, but I'm feeling a bit dizzy. No, I'm okay. But I'll stay here." I forced myself to speak cheerfully, then lay back down.

Like an artist with charcoal, I tried sketching the movements of those thin white fingers as they tied the piano wire around the tree. Onto that picture I superimposed my memory of long white fingers holding a pair of pliers and attaching the wire to our antenna. I shuddered . . . Clean, quiet, skillful, untiring fingers. Fingers swimming toward someone through the dark streets of this area. A pale head and pale fingers bobbing around above my rigid body.

The ceiling started creaking again. From over my head I could just catch the sound of someone speaking.

"That's it. Put your legs on either side of that ridge and then sit down. You've got to hold on with both hands. That's it."

Lunch was over and Mikami was back on the roof.

"Nice view from up here . . . So, can I start painting now?"

Asagi was up there too. Damn. The sharp diagonal of the wires attaching the antenna to the eaves must be right there in front of her. She might trip and fall. She might land on the wire. Damn. My body refused to move.

"See the dead cicada under the antenna? I thought about giving it to Castro, but decided not to. It's too old. Not even the birds will eat the really old ones. They're just too moldy."

That was Mikami.

"Shall we bury it? After all, Castro ate so many of its friends. Why don't we dig it a grave?"

Asagi spoke feelingly.

"Good idea. Let's make a cicada grave. After we've finished with the painting. We'll need to wrap it up nicely so the ants won't get at it."

I stiffened in the darkness like a minnow beneath a rock at the sound of people's voices above the surface. I heard my wife's voice from far away. "Oh, the green is really lovely! It goes so well with the white!"

I could feel the piano wire bite deep inside me—cold, quivering, taut—which is why I never got back to doing any more painting. From one angle there was no proof at all, but from another I just couldn't shake the thought that I had all the proof I needed, and I was scared and stayed hidden in the darkness of my room listening to the creaking of the roof.

I went outside in the evening, and both the roof and the wall facing the storage shed were done. After finishing the roof, Mikami had helped paint the wall. The gently sloping roof raised its green gable into the indigo sky, while the glow of the four white walls outshone their twilit surroundings.

Mikami and Asagi were squatting at the foot of the cherry tree to make the cicada's grave. Mikami had his back to me as he

dug the hole and I prayed he wouldn't turn around. But when they'd finished, he came over and gently asked: "How are you feeling?"

He had taken off his green-flecked goggles and mask; he looked old and tired. The gray-blue seemed to have vanished from his eyes, which now had ordinary brown irises. But his fingers, without the black leather gloves, were as white and thin as ever as they moved like fish through the fading light to coldly clasp my hand.

"Every time I walked past your house, I felt the urge to do it up like this. It worked out well in the end. It looks great."

He sounded pleased, if tired. He didn't say it in so many words, but I was sure this was his way of saying good-bye. My wife looked tearful.

Mikami slowly walked off home down the avenue. The four of us and the duck watched his back until it was out of sight. Yellow autumn leaves were lying on the ground. Like phantom music, *Innocence* came filtering through the cherry trees. I felt as though piano wires invisible to the naked eye had been tied between the trees and were stirring faintly in the air.

Nekos the cat came back that evening.

A week went by. The music coming through the leaves and branches changed to Beyer (or reverted to Beyer, I suppose). But Mikami never came back. Nor did the bikers. They didn't come even after a fortnight had passed.

We never talked about what had happened nearby. Just once, Akane said: "I wonder what kind of noise it made. Probably a short, sharp *sheeeee* . . ." No one reacted.

When three weeks had gone by, I heard a rumor that Mikami had moved away. He never contacted us and we pretty much stopped talking about him.

We got on with our lives, not worrying too much about anything. Had Mikami-san *really* been here? Sometimes I almost had my doubts about it. Our only regular visitors now were direct mail, newspapers with loads of advertising inserts, and cartons of milk.

In December we celebrated Asagi's birthday. My wife spent a long time making Asagi's favorite dishes—egg custard, and fried rice with fish and vegetables. The rice was nice and fluffy and the shiitake mushrooms, French beans, burdock and deep-fried bean curd tasted great.

"Adding sake to rice makes it soft when you cook it. Just a couple of tablespoonfuls," she said, her cheeks bulging with rice. I picked up a strip of black devil's tongue. I noticed that my wife's nose was again riddled with blackheads. Like the spots on the devil's tongue.

Looking around the living room, I saw that the air plants were coated with dust. The water in the goldfish bowl had started going cloudy. There were socks lying under the sofa. In the kitchen, stuff had come back with a vengeance. A leaning tower of dishes rose from the sink. Spectacle-shaped trousers lay abandoned out in the passage. The duck, his feathers mucky with droppings, was croaking to himself outside. Around our feet the tide of clutter was coming steadily in.